PAINTING FLOWERS WITH WATERCOLOR

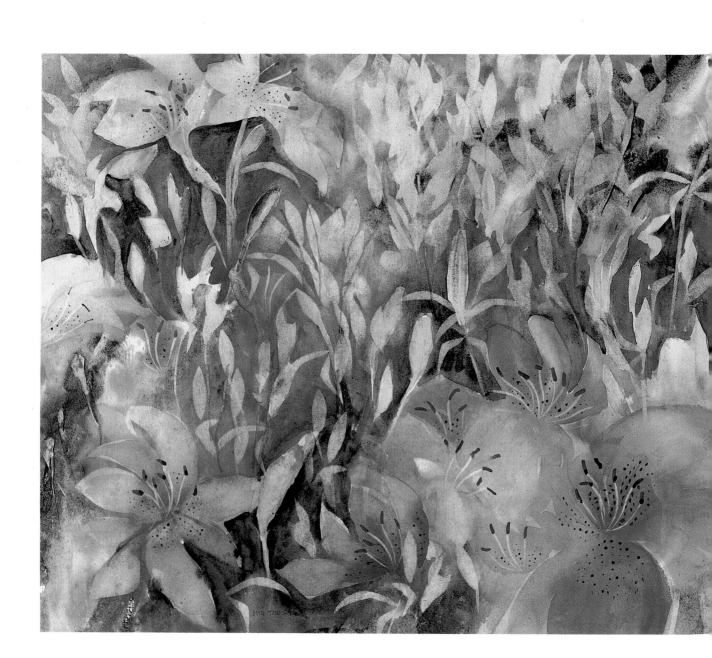

PAINTING FLOWERS WITH WATERCOLOR

Ethel Todd George

Foreword by Diana Kan

Photography by Sing-Si Schwartz

NORTH
LIGHT
BOOKS

Manufactured in Spain
First Printing 1980
Second Printing 1982
First paperback printing 1985
Second printing 1987

Published by NORTH LIGHT, an imprint of WRITER'S DIGEST BOOKS, 9933 Alliance Road, Cincinnati, Ohio 45242.

Library of Congress Cataloging in Publication Data

George, Ethel Todd.
 Painting flowers with watercolor.

 1. Flowers in art. 2. Water-color painting—
Technique. I. Title.
ND2300.G46 751.42'2434 80-24195
ISBN 0-89134-079-3

Edited and designed by Fritz Henning
Composition by Commercial Printers of Connecticut.

This book is dedicated to my husband, Alonzo Milton George, and to my daughters, Sally Manderson Luebbe and Martha Manderson Phillips. It is also in memory of my mother, Mary Perin Todd, and my aunt Martha Perin Wernke.

Acknowledgements to those who have contributed to the making of this book.

Contemporary painters of flowers in watercolor:

Catherine Turk Ballantyne
Claude Croney
Diane Faxon
Hardie Gramatky
Barbara L. Green
Joan Heston
Judy Inman
Diana Kan
Robert Laessig
Barbara Nechis
John Pellew
Alex Ross
Glenora Richards
Richard Treaster

Foreword — Diana Kan
Photography — Sing-Si Schwartz
Lorin Leihgeber for photography of flowers for reference
Anita Ross, Polly Frese and Marguerite Foster for flower reference
Joan Heston for reading, listening and art critiques
Joyce Jones, Lucille Somma, Kathleen Faggen Lyons and
Catherine McChord for their assistance in teaching.
Isabella Corwin for help with the repeat design, and to Francoise Puschel for the Schumacher fabrics and wallpaper with repeat designs

Special thanks go to my husband, who has assisted me in countless ways in the preparation and organization of this book. He is a source of encouragement to me and to all my students.

CONTENTS

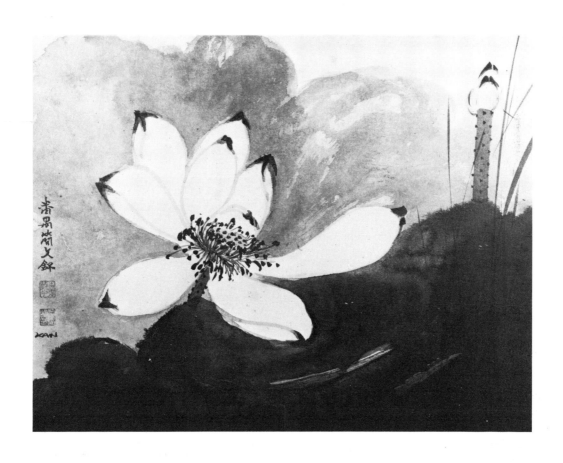

FOREWORD

by Diana Kan

When I first met Ethel Todd George, in 1970, she was already an accomplished artist and skilled craftswoman whose work radiated her lively and imaginative understanding of nature. Yet, she enthusiastically undertook to broaden her artistic perspective, embarking as my student on a rigorous exploration of the intricacies of Eastern painting.

Our studies began with the flowing but well-groomed strokes of calligraphy, from which all Chinese painting proceeds, and progressed through floral compositions in *mo ku* and in contour style to the traditional modeling strokes and multilayered washes of Chinese landscape. Throughout our long association, I have continued to be impressed by her unfailing devotion to art, her astute powers of observation, and her ability to absorb and use new ideas.

In this book of flower painting, Mrs. George expresses the culmination of her many talents and ardent interests. With her expertise in the far-ranging fields of botany, traditional American watercolor, and Oriental brushwork, she is well-prepared to explain the techniques for portraying floral subjects with waterbased media.

Painting flowers in watercolor is not easy. First, watercolor is an elusive medium. To some, it lacks both the flexibility of oil and the pinpoint accuracy of pen and ink. Yet, when properly used, it is perhaps the medium most suited to convey those qualities of bud and blossom which delight us most—delicacy, subtlety, fragility.

Second, stroke and tone cannot be applied haphazardly; they must be based on form. Good painting, therefore, requires careful observation and analysis, or the delineation of form may easily elude our brush, however great our mechanical gifts may be. To achieve the certainty of touch that comes equally from knowledge of the underlying form and from mastery of the brush is the artist's true task.

The artist who aspires to paint with perception as well as skill will find much guidance in these pages. Students will see what they may have overlooked before. One must first see color reflected in the white petals of a narcissus as it nods its head in the breeze, one must see its inner trumpet fringed with red before a painting can even begin.

Diana Kan is a noted artist, lecturer and educator. She is the author of *The How and Why of Chinese Painting*.

INTRODUCTION

Both of my grandmothers had gardens filled with fragrance and constant color from earliest spring through November. They not only had gardens, but solariums where flowers were always in bloom. My mother and her sisters studied botany and flower painting on china, and one sister was a serious art student of Frank Duveneck in Cincinnati and Joseph Henry Sharp in Europe. This was my introduction to flowers and to painting.

Flowers were always a part of my life, although as a girl of sixteen I was more accomplished as a horsewoman because of my father's keenest interest—the breeding and training of racehorses. I was born on his Ohio racehorse farm and became an expert rider, just as he and his seven brothers had done. Horses had been a part of the Todd family tradition since before the Civil War, and continues today.

In college I studied zoology rather than botany, preparing for a career in medicine, but even then my love of flowers was dominant. Luckily, my husband shared this affinity, and early in our marriage we had a large flower garden in Shippan Point, Connecticut, where a hundred species of iris and roses were mainly his province while I tried to keep up with our small children. I managed to find time for the Shippan Garden Club and to study flower arranging—but he was the real gardener!

And now, after years of painting flowers, of study with eminent painters, and as an art teacher, I decided to write a book about flower painting. My shelves are filled with books from my mother and aunts, who were themselves artists and founders of many Ohio garden clubs. With notes and references compiled during my years as a student and teacher, I combined what I have learned as a painter. This book is the result.

Man has always been preoccupied with finding images of his gods, discovering the world around him—and discovering himself. In searching for these images, man was seeking the spirit, the unseen. He began to discover nature, began discovering himself, and began learning to give visual expression to his emotions and thoughts.

Cavemen were interested in art as magic and as power over animals. The Egyptians progressed from art as magic to images of gods for the preservation of the soul. Tombs along the Nile reveal paintings of flowers, especially the papyrus and lotus, symbols of eternity. The Greeks were preoccupied with the beauty of life in their world, while the Romans were concerned with more practical matters of government and empire.

During the Renaissance, painters began to discover the natural world, painting illuminations of flowers and vines, as well as landscapes filled with flowers and plants. Until the 17th century, flowers related mainly to philosophy and religion. With growing enlightenment came a gradual awakening to poetry, philosophy, and understanding of ordinary people of noble spirit. In the 18th century, a more frivolous period, flowers were painted in abundance. With the 19th century came impressionism, followed by expressionism, fantasy, and the abstraction of the 20th century.

Different periods, different philosophies. In our age, art is more varied, more complicated. For a better appreciation of painting in our time, a mutual exchange of respect must occur between the artist and his viewers. The related fields of music and literature

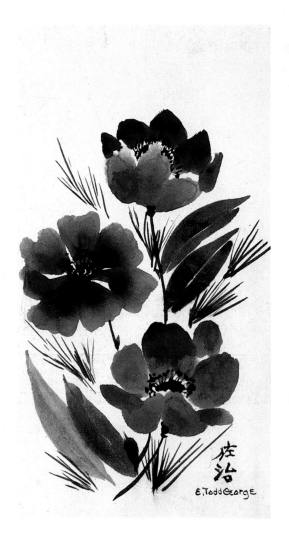

E.Todd George

require this same perception and understanding.

In my experience, great teachers have been those with a feeling for beauty and meaning in life. They are alert to the world around them, and see beyond the obvious in their search for self-discovery and expression. Robert Henri, Paul Travis, Diana Kan, Johannes Itten, Richard Treaster and many of the teachers I have studied with are such people.

Robert Henri's *Art Spirit* is a classic handbook for every feeling painter. Paul Travis's lectures were an inspiration to all those who heard him.

Diana Kan's philosophy includes such words as:

"One ought everyday
to hear a little music,
read a good poem,
see a fine painting
and, if possible,
speak a few kind words."

Diana Kan lists the six canons of the renowned Chinese painter Hsieh-Ho:

1—Spiritual quality generates rhythmic vitality.
2—Use the brush to create structure.
3—To establish the form, write its likeness.
4—Apply color in accordance with nature.
5—Plan the design with each element in its proper place.
6—Study by copying the old masters.

However, before painting, learn poetry, calligraphy, carving—and be a good person. The natural forms we paint as symbols of life are also symbols of virtue: for perseverance, hardihood, modesty and purity, fortitude and patience . . ."Patience endured is mastery achieved."

There must be understanding and feeling to express nature and beauty, to explore the relationships of design, and to express the essence of life itself in the subject of flowers. Flowers can bend; they can respond to the wind and to the rain. Petals can lift to the sun. Leaves can dance in the breeze. To understand them, go to nature and learn from real flowers.

Richard Treaster feels a deep religious or spiritual knowledge as distinguished from material knowledge. He lays special stress on understanding the underlying unity of all life, the presence in the universe of one great spirit of which all existence is part. He puts emphasis on individuality and expression of one's feeling, and encourages uniqueness of expression.

Among the oldest religious scriptures in the world are the Vedas of India. In them, spiritual knowledge is distinguished from material knowledge. A wise old father used the following selection to preach the gospel of the one great spirit that animates all life to a somewhat over-educated and supercilious young man, too full of book-learning:

When Svetaketu, at his father's bidding, had brought a ripe fruit from the banyan tree, his father said to him:

"Split the fruit in two, dear son."

"Here you are. I have split it in two."

"What do you find there?"

"Innumerable tiny seeds."

"Then take one of the tiny seeds and split it."

"I have split the seed."

"And what do you find there?"

"Why, nothing. Nothing at all."

"Ah, dear son, but this great tree cannot possibly have come from nothing. Even if you cannot see with your eyes that subtle something in the seed which produces this mighty form, it is present nevertheless. That is the power. That is the spirit unseen which pervades everywhere and is in all things. Have faith! That is the spirit which lies at the root of all existence, and that also art thou, O Svetaketu! "

To express more than mere technique, we must use emotion; to understand we must seek beyond that which we think we see. We must try to paint with head, hand and heart. With faith.

"Discipline endured is mastery achieved."

CHAPTER 1

MATERIALS

A check list of materials for painting in watercolor:

1—Paper
2—Sketchbook
3—Board to support paper
4—Clips and tape to fasten or hold the paper
5—Water and water containers
6—Sponges (natural and synthetic)
7—Palette
8—Paints
9—Tissues, towels, rags
10—Brushes
11—Palette knives
12—Miscellaneous: easel, table, stool, umbrella, bug spray, pencils, erasers, pens, ink, single-edge razors, ruler, stapler, plastic scrapers, credit cards, maskoid, maskoid lifter, fixative, blotters, elastic bands, matches, wax crayon (including white), plastic envelopes, portfolios, salt.

Of course, not all of the above materials are necessary. The "Whiskey Painters of America" travel with the tiniest palette, brush, and pad of paper—just enough to slip into one small pocket. They find liquid at any bar, or wherever they wish to paint.

My outdoor teachers, Jack Pellew, Claude Croney and George Passantino, travel with only the materials they can easily carry. Painting in your own studio with everything in a certain order is a different situation.

The paper, paints and brushes you use should be the best you can afford. It is discouraging to attempt a fine painting on wood pulp paper with poor quality paint and a brush that does not have a point or capacity to spring back to a point.

A sketchbook and a plan before painting are necessary unless from years of experience you can plan your painting in your head. Order in the set-up of your materials, fresh paint, clean water, and a courageous attitude prepare the way for the best painting.

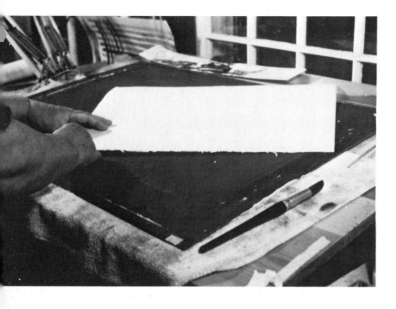

PAPER

There are many kinds of papers for watercolor painting. I use the best I can get. Grumbacher and Winsor & Newton are among the companies listing these papers. Paper can be purchased by the sheet, the quire (25 sheets), the ream (500 sheets), or any number of sheets, rolls or blocks. The best papers are identified by watermarks of initials, names or seals. Some of the best are Arches, Fabriano and Strathmore.

The best papers are made from linen or cotton rag. Some papers contain wood pulp, which is not as good. There are also papers and silk boards from the Orient. These contain fibrous cellulose material reduced to a pulp from the paper mulberry tree, bamboo and rice. Sizing is added to the paper to give it strength and to reduce absorbency—and this resists paint unless it is sponged with water.

Paper is made with different characteristics: rough, cold press, and hot press. Cold press surface appears rough or not-so-rough, containing little bumps, hills and valleys. The surface of hot press is smoother and less absorbent.

Watercolor paper is listed by name, weight, rough, cold press or hot press. A ream of 22 x 30 inches (Imperial size) can weigh from 70 to 400 pounds. The thinner paper and paper in blocks (with the edges sealed) tends to buckle when wet. The blocks tighten as they dry; the thinner sheets are best stretched.

Watercolor paper also comes in larger sheets called "elephant," "double elephant" and rolls. Blocks come in different sizes, and usually have 20 to 24 sheets. The small blocks are easy to carry for trips where luggage is limited.

I use Arches and Fabriano in both 140 and 300 lb. weights, with cold press surface. I also use Strathmore papers and boards. For brushwork, rice paper, Masa paper, rice boards and silk boards are excellent. Sometimes I use Austin colored tissue papers to start abstract designs, and for textures with acrylic medium and watercolor.

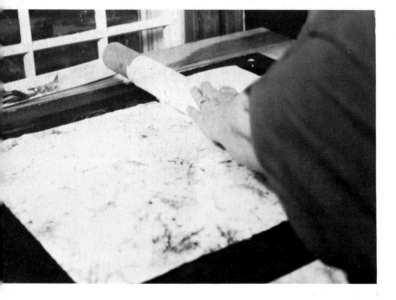

BOARDS

Drawing boards can be made from many materials in addition to wood. Plastic, glass, plywood and masonite work well. 5/16 inch tempered masonite makes a good board for half-sheet and quarter-sheet watercolor paper. For the most simple stretching, a board 16 x 23 inches is large enough for the half-sheet paper, while 12 x 16 inches is enough for the quarter-sheet. If tape is used, or if the paper is backed with another glued paper, the board must be larger.

CLIPS & TAPE

Metal spring clips, large enough to fasten over the paper and the board, are used to hold paper to boards. Smaller clips can be used to hold papers together, or to hold a sketch to the watercolor paper.

Masking tape of various widths can be used to fasten paper on boards and mats. Drafting-type masking tape is easier to remove when used to block a line or mask out an area. Clear plastic tape can be used to fasten notes to paintings. Two inch wide brown paper tape (with glue on the back) is used to fasten stretched paper to a board.

WATER CONTAINERS

Quite often a beginner will use just one small glass for water. Two quart-size glass or plastic containers are much better. One container should always be kept clean for mixing with the paint; the other can be used for washing the brushes or painting with "dirty water." A wide-mouth jar or bowl is easier for working with a large sponge. A large jug of water carried in the car is needed to supply smaller jars or containers for some outdoor painting.

SPONGES

Natural sponges in small and large sizes are used for wetting paper and for lifting paint. Natural sponges do not destroy the surface. Artificial or synthetic sponges are used for cleaning and for patting wet brushes to absorb extra water. They can be used to keep moisture in a palette if not left too long.

PALETTES

My first palette was the one that came with a 6 x 12 inch O'Hara box. It was white enamel on metal. Usually such palettes don't last too long because the enamel peels off and the tray gets rusty. A new one should be given several coats of plastic spray to prevent peeling.

My second palette was of beautiful plastic with four separate enamel trays and a well, fitted with ceramic pans for paints, and a felt-lined cover. This is fine for studio and everyday painting, but it is too large to carry outdoors and tends to keep the paint too moist, encouraging the development of mold. I use the enamel trays in my studio, but not the ceramic paint pans.

A third palette was the good old butcher's tray like those used by Hans Walleen and Herb Olsen. When a mound of paint becomes too dry, I soften it with a drop of glycerine. There is still usable paint on my butcher's tray from years ago. I pull it out to lend to students who forget their palettes, or sometimes I use it when I need more color.

The palette I use most now is the Pike plastic palette. It holds lots of paint and has a good mixing area. It also fits into my canvas bag, has a good cover and is easy to carry.

Some artists carry smaller palettes or palette paper normally used for oil paints, on which they squeeze out fresh watercolor paints each time they paint. Plates, plastic boards and glass with white paint or paper underneath also serve well as palettes.

PAINTS

Tubes of Winsor & Newton artist watercolors, Grumbacher Finest or Permanent Pigment, a minimum of twelve colors, make a good beginning. I have more colors than any of my palettes hold, and like to experiment with different yellows. Sometimes I use many different reds and violets in flower painting. For different greens I usually mix those I want.

My twelve standard colors are cadmium lemon, cadmium yellow, cadmium orange, cadmium red, alizarin crimson, yellow ochre, raw sienna, burnt sienna, raw umber, burnt umber or warm sepia, ultramarine blue, and cerulean blue.

In addition, I often use Winsor yellow, which is a lemon yellow, cadmium yellow pale, aurora yellow, gamboge and New gamboge, aureolin yellow, and Indian yellow.

When painting flowers, I use permanent rose, rose madder, genuine cadmium red light, cadmium scarlet, and vermilion for additional reds. Cobalt violet and Winsor violet are useful. In addition, I mix violet using alizarin crimson and ultramarine blue. The additional blues on my palette are cobalt, Winsor blue, and sometimes manganese blue. Occasionally I have use for Prussian and Antwerp blue. I mix sap green, Hooker's dark green, Winsor green or viridian green with a warm color when I do not mix my own green from a yellow and a blue.

The earth colors are light red or Indian red, brown madder alizarin, Van Dyke brown, charcoal gray, Payne's gray and ivory black.

My first watercolor teacher, Paul Travis, who taught a short course for students of architecture at Case Western Reserve University, remarked that one student had bought a tube of every watercolor made, when for that short course all he needed was red,

yellow and blue. Certainly a great number of colors can be mixed from the three primaries, but it's fun and saves mixing time to have a variety of tube color.

BRUSHES

Try to invest in at least one brush in a small round size, a medium-sized round, and a 1-inch flat. A brush should have a spring to it and hold its shape when wet. A good round brush will hold a point when wet. Sable is best, and the most expensive. A 1 or 2-inch wide flat brush is good for wetting or painting large areas.

Over a long period you will want to collect more brushes. Well cared-for brushes should last a lifetime, if they are of good quality. My favorite brushes are a 1-inch mink aquarelle, which I have had most of my life, and several series 7 Winsor & Newton sables. The series 7 has gone up in price tremendously, because they are made with the finest Kolinsky hairs, by skilled craftsmen. Other makes of the fine sable brushes are also available. Soft hair brushes include those made of sable, ox hair, fitch and squirrel.

My round sable brushes range from the smallest, size #00, to size #14. My flat sables range from ¼ to 1 inch wide. I also have a collection of good quills, bamboo brushes, and brushes made for oil and acrylic painting, which are useful in watercolor. A worn oil brush is excellent for scrubbing out color or cleaning an edge. Don't throw away your old bristle brushes. Even when very worn they work well for scrubbing.

Once I took a bamboo mat brush carrier loaded with brushes to Vermont, only to have Claude Croney tell me I needed only three. Claude was right. Too many brushes can be confusing. I have often painted an entire large watercolor using only one large brush.

STUDIO

The studio should have good lighting, adequate working area, a sink if possible, and storage space. The most beautiful and best organized studio that I have seen is that of Alex Ross. It is two stories high, 25 x 30 feet, with skylights, windows, and all kinds of storage space in closets four feet deep. There is a large working area at one end and a cozy seating area with a big fireplace at the other. This, to me, is a dream studio without the clutter I have in my long, narrow, but happy studio. I do have a good drawing table and side tables for palette, water, brushes, and a table-tote. I have table and shelf space, and above all, a sink with hot and cold water. There is room for five students (the rest scatter throughout the house). There are storage cabinets, a paper cutter, racks for portfolios, stools and chairs, and an old Italian gargoyle over the door to keep evil spirits away.

OUTDOOR PAINTING

For outdoor painting, equipment must meet the needs of the painter. When I was in my first outdoor class with Clayton Bachtel at the Cleveland Institute of Art, we walked to an interesting building near the old school, and to a quaint area of the city known as Little Italy. We drove to boatyards and quarries. I can't remember ever having a campstool. Then I could sit on my heels, the grass, an old log, a rock—almost anywhere. I carried a block or pad of watercolor paper, a small box of paints with room for brushes, and a canteen of water. Later, when I painted outdoors with Billy Grauer in the Amish country outside Cleveland, I added a blanket to my equipment to make it easier to find brushes which could otherwise be lost in the grass. Sometimes I would sit in the trunk of my car so I could paint out of the sun or rain.

Now I have a French easel and a light-weight aluminum watercolor easel. I also take two campstools, one for a painting board and my supplies, and one to sit on when I can't stand. I carry all my materials in a canvas bag. I try to keep my materials as limited as possible, especially when my car is nearby. Some artists have unbelievably elaborate equipment for outdoor painting. An architect friend, Bruce Anderson, of Little Rock, Arkansas, has his table and chairs on wheels, and all kinds of carriers for his materials. Another friend, Roger G. Reuilland, from the Buffalo area, has a fancy table and easel combination.

CARE OF BRUSHES

Watercolor brushes must be kept clean and stored so that their shapes will not become distorted when not in use. After painting with soft brushes, wash them in cool, clean water. They seldom if ever need to be washed with soap. To be sure that all paint has been removed near the ferrule, cup your hand with water and turn the brush around in the water. Rinse and shape or shake the brush into shape and allow it to dry on a flat, level surface. Do not store wet brushes upright in a jar, which would allow moisture to collect in the ferrule. Do not let a soft brush stand on its point in a glass of water while painting, for this will harm the tip. Dry brushes can be rolled in a bamboo holder or supported on a cardboard held in place by rubber bands so that the tips are protected.

Dust and moths are not good for fine brushes. If brushes are stored for any length of time, they should be kept in a closed drawer or box with some moth crystals.

CARE OF PAPER

There are watercolor papers hundreds of years old and still in good condition. The best paper is made from linen rag bleached by the sun without the use of chemicals, but this is rare and expensive. Papers bleached by chemicals and containing other materials besides glue for strengthening should be kept in a dry place. Dampness affects glue. When paper is of good quality and stored flat in a clean, dry place, it can be kept indefinitely.

CARE OF PAINTS

Pigments of watercolor are held together with gum. If allowed to dry, they become hard. I store unopened tubes of watercolor in a metal box. An old cookie box makes a good storage place.

Be careful to clean the tube opening and screw the cap on straight. Hardened paint or tops not screwed on well can make it difficult to open the tube later. Hot water or a lighted match held under the cap for a few seconds can make it easier to open tubes. Force used with pliers can sometimes break the tube, although pliers are helpful if you want to squeeze out that last bit of paint.

PREPARING YOUR PAPER

There are many ways of handling the materials for watercolor painting. In the list of materials needed, paper happens to be mentioned first, and may be used either dry or wet. If it has been sized, it will take the paint better if it is sponged so that some of the surface sizing is removed. If the paper is rough or even slightly textured, as in cold press, it will not take line work or brush strokes as smoothly or easily as smooth paper. The paint will not settle in the depressions unless put on with enough pigment and water. Thus, dry-brushing is possible.

All watercolor papers that tend to buckle when wet are best stretched. When the paper is thoroughly saturated it expands or stretches. It can then be used on a waterproof surface, as in Method 1. Or it can be fastened in several ways to make it "drum tight" as it dries, as in Method 2.

Method 1: Place the paper on a waterproof board. I prefer tempered masonite 5/16 inch or thicker, and a little larger than the paper. Place an old bath towel underneath the board to catch any dripping. Then sponge the paper in large, wet circles, flipping the paper over several times until it is perfectly saturated. This takes time, so be patient. When the paper is thoroughly limp on the board, hold it up to eye level and check for air bubbles. You should see a smooth, wet, shiny surface. The next step is to squeeze the sponge and reclaim the wet surface. This time, when you again hold it at eye level, the paper on the board should have a drier, more matte-appearing surface. You can now apply the large areas of wet-in-wet paint. If a bubble or dry place appears, lift the paper and wet the board underneath. When you do not want the paint to run from one area into another, test your paint in the center of the area to be painted; if it is under control you can proceed. When the outside edges or corners of the paper begin to lift, large clips may be placed to hold the paper to the board. More paint may be added so long as it is light to dark, and not wetter than the surface. If you have too much water in the pigment, the extra moisture will cause a "run-back." This can be an effect you may like, or it can be a disaster. Dry-brush can be continued, or the painting can dry and then be worked on again, either with glazing or soaking and again working wet.

Method 2: Soak the paper in a large pan or bathtub until it is saturated. Lift it out by the corners and allow it to drip for a minute. Then place it on a board or stretcher. There should be no air bubbles under it, and it should be kept flat. It can be stapled to the board or to the kind of wooden stretchers used for canvas, or it can be fastened to the board with wide glue-tape. When using the glue-tape, I cut the lengths needed ahead of time, and sometimes I draw a light pencil-line near the edge for an even border. The glue-tape needs at least ½ inch overlap on the board to keep the paper from pulling inward as it dries.

There are different types of stretching frames made to hold wet paper as it dries. I used a plastic "Boga-Board" stretcher in my demonstration of "Landscape with Daisies." I haven't used it more than half a dozen times. At first it was difficult to center the half-sheet and the edges of the sheet had to be pressed flat afterward; but it works!

I have tried many ways of stretching paper. I even soaked 300 lb. paper in the tub overnight and then placed it on layers of newspapers or blotters without stretching, in order to paint in the wet-in-wet technique for a long period. It is quite easy to control the wet technique with this method, and the heavy paper will dry flat. Dried paintings can also be put in the tub under several inches of water and re-worked in the wet technique.

In addition to linen and cotton watercolor papers, I also use rice paper, mulberry paper, and various other Chinese and Japanese papers, including Masa, silk, and Austin tissue, as well as 140 lb. and 300 lb. cold press Arches, Fabriano, and Strathmore board.

When not being stretched, the paper can be placed on your table without being fastened, or it can be taped with masking tape or held with clips. If it is sized, it can be sponged on one side and dried, or sponged as you paint.

If the paper is on a backing board for easel painting, it should be clipped, stapled or taped. The board, the paper, and your preference determines the method. Sometimes it is nice to finish a small painting, pull the tape from around the edges, and have a white border. At other times, the white border makes the painting too small for the standard mat-opening, or not the right size for a white liner.

CHAPTER 2

WATERCOLOR PAINTING TECHNIQUES

Watercolor is a medium for exploration. So many exciting things can happen if you try for different effects. There is almost no limit to what you can use or how you can use it. Plunge right in. Practice, experiment and let your imagination go. Get yourself a lot of inexpensive paper and try to create the kinds of effects shown here. Then explore on your own. Who knows what kind of effects you can create until you try. One way or another, all of the effects you learn how to make can be used in painting flowers. The important thing is to avoid working too hard to achieve the effect. Watercolor is best when it is kept simple and direct. The most difficult thing is to keep your effects from looking overworked. One of the hardest things to do is to wash in the effect you want then leave it alone.

FLAT WASH

Flat wash is a basic technique. A mixture of pigment and water to create a film of transparent color is applied in a series of parallel strokes. The first stroke is picked up with the second, to avoid variations. When the paper is held at a slight angle there is a bead of wash at the bottom to be picked up. This is continued without gradations or variations.

Start with a small sheet of paper fastened to a board. Experiment with squares, rectangles, cylinders and various shapes from small to large until you have some idea of how much paint to mix and water to use and how to apply it evenly.

GRADED WASH

The graded or graduated way is similar, although it differs in that either more pigment or more water is added as the strokes are continued so that the wash moves from dark to light or from light to dark.

GRANULATED WASH

The granulated wash is achieved when one pigment is washed over another so as to cause granulations. When opaque pigments are washed over the paper they do not settle in all the valleys, as do such staining colors as the thalos and alizarin crimson. When a second opaque color is washed over the first (the paper can be tilted back and forth to cause more running), the granular effect is quite pronounced. Try a wash of yellow ochre over an area. Let it run down from the sky top to the horizon. Reverse the paper. Repeat a wash of cerulean blue from horizon to sky top with the paper tilted so that the cerulean wash runs in the opposite direction. Notice the granular texture.

GLAZING

In watercolor, glazing is a technique of wash over wash without disturbing the first wash or lifting the bottom color. The bottom color should be of a staining pigment—not sedimentary, and the top colors should be sedimentary. For instance, alizarin crimson is a beautiful staining color. A wash of alizarin crimson, allowed to dry and then covered or partly covered with a wash of yellow ochre will help to achieve dual color and textural color which is impossible to achieve with a single wash. To pull it all together, a warm color can be washed over a cool color, a pigmented or sedimentary color over a staining color, or a wash over the complete painting when it is nearly finished.

Listed under staining colors are scarlet lake, Winsor or thalo violet, Winsor or thalo blue, Winsor or thalo green, raw sienna, burnt sienna. Other colors also have staining properties, as you may have perceived. Listed under sedimentary colors are cadmium yellow, orange and cadmium reds, cobalt violet, cerulean, terre verte, brown. Some of the blues such as ultramarine, cobalt and manganese have some sediment. Viridian green and some of the earth colors, such as yellow ochre, the siennas and the umbers, have a little sediment.

In glazing, it is a good idea to make a chart and experiment with the colors you have. Not all watercolors are the same. Some of the inexpensive colors are unpredictable. Unfortunately there never has been a cheap watercolor that will give the best results.

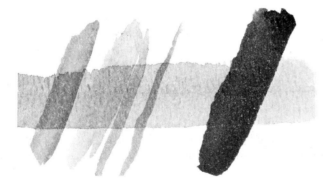

WET-IN-WET

The wet-in-wet technique is simply adding paint and water to a wet surface, either to wet paper or over a wet wash area. This is a process of spreading paint and water in different ways determined by the amount of wetness of the paper and the amount and kinds of pigment applied.

DRY BRUSH

Dry brush is applying pigment with little water in the brush to dry paper. For best results the paper should be rough. The brush can be held at an angle so that the tips do not sink into the valleys of the paper. The brush can be moved rapidly. Sometimes it is desirable to flatten and separate the hairs of the brush with your fingers or by stamping it on a tissue. This procedure keeps the pigment and water from flowing onto the paper in a smooth, even stroke.

SPONGING

Some of the techniques are self-explanatory, such as sponging in color dry or wet. Various sponges create different effects.

STIPPLING

Stippling is done with the tip of a stiff brush or a stencil brush. It should not be too wet, so that a texture of tiny dots is made on either dry or damp paper.

SPLATTER

Splatter is done with a loaded brush tapped against your hand, ruler or a heavy brush handle. The direction of the splatter depends on the way the brush is held and tapped. Practice before you splatter to get the feel of how much pigment to use and how hard to strike. Splatter can also be done effectively with a toothbrush. Load the brush with paint, hold in the appropriate position and run a sharp edge or your finger over the bristles.

SPOTTING

Spotting with water can result in "run-backs." Here paint is carried away with the water and a little ring or spot results. This can create an interesting texture. I have seen patterns of water-spotting that looked like batik designs. Large spots can be made with large drops of water, and a mist of very small drops can be made with a fine spray. A toothbrush is a useful tool for spotting with water.

SALT

Salt is a painting gimmick but, at times, it can add unique textural effects. It can be used on fresh paint, or on a layer of fresh paint which has been applied to a previously painted surface. Plain table salt or coarse kosher salt can be applied either from a salt shaker or by hand. The right degree of wetness and the amount of salt can best be determined by experience. The paper should not be shiny-wet, nor too dry. Too much salt will absorb too much pigment. Overuse of salt can ruin a picture as it can spoil a good recipe.

OFF-BEAT TOOLS

Also in the not-to-be-overused department are effects you can obtain with a squeegee, credit card or cardboard. These tools make good straight lines of different thickness and colors. If several colors are worked into a little water on the palette, so that several colors can be scraped onto the applicator, a line pulled sideways can create several different colors. A line pulled straight can be very thin if the paint picked up is not too thick or too wet. Again, experiment and use sparingly.

INK

Ink can be used with either a pen or brush, immediately followed with a clean wet brush to cause it to flow and create a soft edge. Ink on a pen or brush can be added to a wet or damp painting so it will flow, or to a dry painting for accents. Black ink can be added to a color to make it darker. Brushes or pens used in ink must be thoroughly cleaned after use. I do not use my best sable brushes in ink because I do not want to wash them with soap. I wash brushes used in India ink with Ivory soap and tepid water, working the brush in the palm of my hand until the water is clear. When I use Chinese ink made with the ink stick, I wash the brush in tepid water only until it is clean.

FAN BRUSHES

Fan brushes are useful to make tiny spreading strokes, like fine, distant twigs at the tops of trees, or grass. If you do not have a fan brush, you can achieve the same effects by carefully separating the hairs on any brush and tapping out the extra moisture. If the brush is pressed down and then lifted with a flipping motion, the strokes can be made from thick to thin.

SQUEEZING PAINT

Squeezing out paint is done with a palette knife or a plastic squeegee. The paper must not be too wet or the paint will flow back to make a dark line. While the paper is still damp but not shiny wet, the paint can be squeezed with the knife or squeegee held at about the same angle as a butter knife when spreading butter (not as in cutting), and the paint can be squeezed vertically or in leaf-like shapes.

SCRATCHING

Paint can be scratched out with your fingernail, tips of brushes, knives or razor blades. This can be done when the paint is matte-dry (not shiny-wet), or with sharper tools if the paper is thoroughly dry.

MASKING

Masking on watercolor paper is done by using masking tape, maskoid, rubber cement, wax crayons, a candle, or wax. The paper must be of sufficient strength and quality to withstand this process. Some papers will lift or tear when the masking tape or maskoid is removed.

Drafting tape or regular masking tape can be cut to the sizes or shapes of the area to be blocked out, then removed after the paint has dried.

When using maskoid or rubber cement, I use brushes saved just for this purpose. In a small box I keep the maskoid, a small bottle of thinner, Ivory soap, and some maskoid lifters as well as an assortment of brushes.

Before applying the maskoid, I work the brush in a small amount of soap, then paint the maskoid on the area as though I were applying paint. The brush must be good enough to accomplish this well, although it does not have to be your best painting brush. When the masking is finished, I immediately clean the brush and the top of the maskoid jar with a tissue. Next, I wash the brush in thinner and follow with a wash in soap and tepid water.

The maskoid must be perfectly dry before it is removed. Colors painted over the maskoid can be light to dark, but should contrast with the white paper when the maskoid is removed. Sometimes I press masking tape against the maskoid to be removed. It usually lifts with the tape. Other times I rub off the maskoid with my fingers, or use a commercially made block or roll of the lifter.

Maskoid leaves hard edges. A white flower can be lost in the background and edges can vary; it is then easier to paint around without masking. When you want to apply color loosely, where white is difficult to save, masking can be useful. When paraffin or wax crayon is used, the wax can be removed with a hot iron. Place absorbent papers over the area when the paint is dry and apply the iron. The melted wax will be lifted off your picture and absorbed into the covering paper.

LIFTING OFF COLOR

Color can easily be lifted without causing edges to change if it is sponged out while the paper is quite wet. Color can be lifted with hard, clean edges when sponged out between blotters, heavy cards, or masking tape. Shapes can be cut from stencil paper to be used for lifting color in from that shape. For example: a bird in the sky, a pale leaf, a small boat in the distance, or a church steeple.

A thirsty brush (a brush squeezed almost dry) can lift color provided it is not completely dry. An old bristle brush can scrub out dry paint or soften an edge of paint. Follow this with a tissue for blotting.

EDGES

Edges vary. Some edges can be hard or sharp, made with a brush loaded with paint and the right amount of water. Other edges can be rough-brushed with an almost dry brush, using a quick stroke with the brush held with the handle almost parallel to the paper. An edge painted off with water of another color while still wet can be wet-blended or lost.

DROPPING COLOR

Using only water, try painting a line, a post, or a tree trunk and branches. Then drop colors into this water. Let them run together a little, or tip the paper to cause more running, and notice the interesting variations.

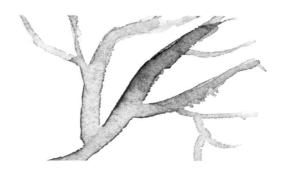

OTHER EFFECTS

For additional special effects and painting procedures see the step-by-step demonstrations starting on page 61.

a. Using real material — leaf

b. Cardboard edges

c. Painting opaque with painting knife

d. Lifting paint using stencil

e. Watercolor with detergent

f. Painting with palette knife

CHAPTER 3

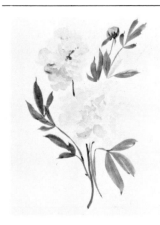

PLANNING TO PAINT FLOWERS IN WATERCOLOR

Painting flowers in watercolor is quite different from painting in oil or acrylics. It is more spontaneous, less detailed and fresher. Detailed work can be done with small brushes and tempera techniques for botanical studies; however, that is not the purpose of this book. These watercolors range from fairly realistic to impressionistic to abstract. All are done with freedom and pleasure.

Before painting, become as familiar as possible with the subject. Read the chapter "Painting from Nature." Next, know your materials and at least a little about how to use them before you think of a painting. Try sketching. Try painting techniques. Learn something about papers, brushes, and other materials.

Design elements and design principles should also be practiced to better prepare the way for compositions. In all of my teaching, I have started with drawing and then design. It does not have to be boring. It can be interesting if you desire to learn.

Design elements to consider are spot, line, shape, color, space and texture. The principles have to do with the way you organize these elements to create harmony and unity. Dominance, variation, focal point, repetition, movement, unity, color, contrast and balance are all part of composition—designing a picture. (See examples.) Pleasing aesthetic relationships and expressiveness create works of art. Good design is the essence of all art work.

After you have selected a subject, know your materials, studied design, drawing and painting, you need a plan for composition before you begin a painting. There are many ways to plan a composition.

Here is the procedure I usually follow:

1 Make a small pencil sketch in proportion to your paper or no larger than 5 x 8 inches. I usually work smaller.

2 Paint a small watercolor (5 x 8 inches) only in shapes or areas of values using only one color or burnt umber. Have light, middle and dark values. When you develop a pleasing abstract pattern, decide on the colors you wish. Remember color not only has *value,* but also *hue* and *intensity.*

3 Try a small painting in color. Practice the techniques and colors on a separate sheet or scrap of paper before adding them to your painting, if you wish.

4 Work from a plan.

5 Work from back to front.

6 Work from large to small.

7 Work from light to dark.

8 Consider the focal point for greatest contrasts.

9 Relate the pattern of darks.

10 Relate the pattern of lights.

11 Check the shapes for two-dimensions, interlocking, and variations in the edges.

12 Check for gradations in the elements.

LINE DRAWING

Drawing and painting of flowers can begin with a dot. When the dot moves in any direction, it can create a line that can move across, up or down; or an oblique, with a bend or a curve, or with a swirling whirl. The line can be as delicate as a whisper or as heavy as a shout; it can suggest things—it can suggest feeling. There are many kinds of lines in the painting or drawing of flowers as in all the visual arts. In flowers, as in all nature, there are few straight lines. Lines in plant materials are natural, graceful lines.

Many painting teachers have their students begin by drawing and painting lines with various tools and media. Regardless of how you draw lines you must visualize them first—or feel them and respond to your feeling about the kind of line you wish to draw. Thinking of quiet water, you visualize quiet, horizontal lines. Thinking about surf and breakers, you visualize tossing, curved lines. Listening to a symphony, you'll probably think about quite different lines than when listening to jazz. Your feeling when you see a delicate rose will make you touch the paper in a way different than when you see a thorn.

Lines may be contour lines, gesture lines, or lines made in ways to create tone or shading. Lines can be straight, curved, broken, continuous, long, short, heavy, delicate, precise, wiry, vibrant, textured, thick, thin, jagged, swirling or bent. Lines can suggest weight, motion, outlines and direction, and have emotional expressiveness. Lines not in contrast to backgrounds can have low intensity and be lost. Lines in strong light can be lost. Interrupted lines have lost parts. Lines with contrast of dark against light or light against dark can have high intensity and stand out. A line painted on wet paper can feather out in interesting textural designs.

Cézanne saw lines in nature pointing toward a central point in proper perspective. He saw lines parallel to the horizon giving breadth, and perpendicular lines giving depth. Van Gogh saw swirling lines giving the feeling of stars whirling in his painting "Starry Night," and much of the feeling he has in his flower paintings is expressed with the same kind of surging brush strokes.

With just a few lines, the master artists of all cultures captured people's feelings about life around them. From the time of the earliest cave drawings, artists have expressed their art with simple lines to tell us their thoughts, feelings and discoveries about their world.

In *The Natural Way to Draw,* by Kimon Nicolaides, the first illustration is a contour drawing of a lily, by Matisse. He feels the curves, shapes, proportions, rhythms and essence of the lily. Contour drawing is called "drawing with feeling."

To do a contour drawing from the feeling or experience of touching as Matisse did when he drew

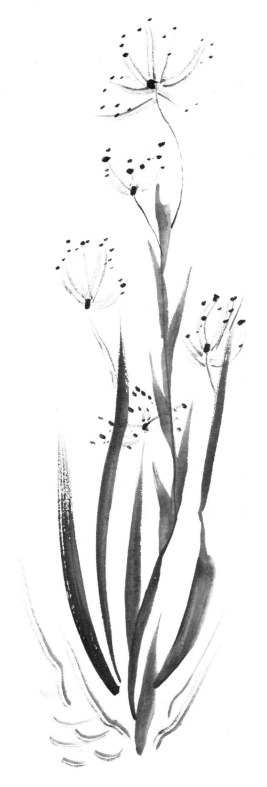

Practice with whatever drawing tools you wish. Don't worry about drawing specific things. Try to get the feel of creating different lines and effects.

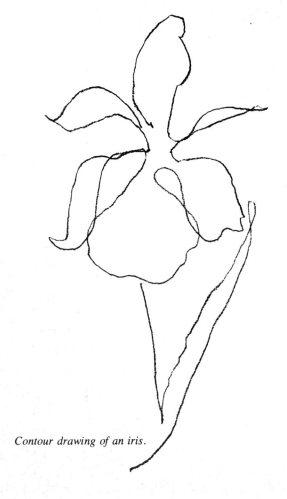

Contour drawing of an iris.

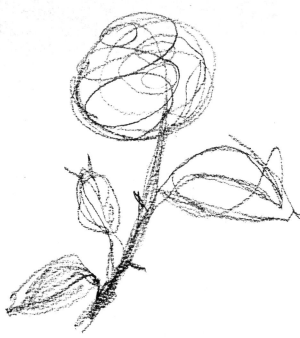

Gesture drawing of a rose.

the lily, fasten a piece of paper to a drawing board, so that it will not slip. A soft pointed pencil is a good tool. Sit where you can observe a simple plant, such as a flower on a stem, with leaves and buds. Study the plant. Don't just look at it, but study it. Touch it. Feel the texture of the petals and the foliage. Smell it. Some plants have delightful fragrance. If it is an herb, taste can also increase your sensual awareness.

Now place your pencil on the paper at a point where you wish to begin the flower study in contour. Focus your eyes at that point on the flower. Imagine that your pencil is touching the outline of the flower as you see it.

Now, without looking at your paper but carefully observing each curve and each direction, let the pencil move slowly along the paper as your eye moves slowly around the flower. Be guided more by the feeling that you are touching the plant, than by sight. This means you must not look at the paper while you are drawing, and that you must not lift the pencil. When you think you have finished one continuous line, and you wish to draw an added shape or parts within the shape, you may then look to find the starting point.

Focus your eyes on this point on the flower and the pencil at the same point on the paper, but when you begin to draw again, look only at the plant, not at the paper. Where you feel softness, press softly on the paper; where you feel strength, press harder. Put feeling into your drawing.

Gesture drawing is different from contour drawing. The subject is explored all around, not just as an outline. Gesture drawing is done quickly. It represents a certain kind of concentration, even though it is done rapidly. It is a good way to "loosen up." The gesture explores height, width, roundness—what the subject is *doing,* the *action,* more than what it looks like. The gesture is *dynamic,* moving, not static. Gesture drawings have no precise edges, no exact shape. It is movement in space.

To draw the gesture of a plant, use a medium or soft pencil. Fasten drawing paper to a board or support. Study the plant. Draw rapidly and continuously in a ceaseless line, from top to bottom, around

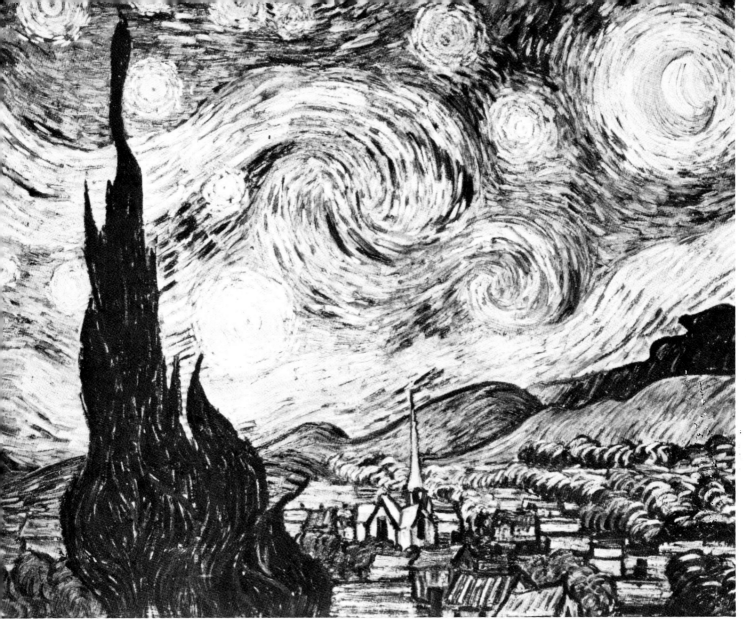

The Starry Night
Vincent Van Gogh

and around, without taking your pencil off the paper. Let the pencil roam and report the gesture just as you would if you took yards of string or yarn and wrapped it around the plant. Focus on the entire plant; keep the whole thing going at once.

Drawing with shading is still a different approach to the study of flowers through lines. A variety of pencils and pencil strokes may be used. Build up the *values* to create an interplay of white, gray and black.

In line drawing with wash, the artist is concerned with lines made with all kinds of tools including brushes, pens, pencils and sticks.

Lines can be made with all kinds of tools and with many different approaches. Should you think, "I cannot draw a straight line," try this approach: Fasten a piece of paper to a board, then think of a word. Respond spontaneously, without stopping to think or speak, by drawing a line symbol for that word. Try it with ink and a Chinese brush, using such words as hush, symphony, explosion, jazz, woman, crash. Many who have tried this experiment thinking, "I can't draw a straight line" find they have no need to, and discover they have a hidden visual talent.

33

LINE IN FLOWER DESIGN

Line in flower design can delineate shapes and patterns. It can create rhythms that unite a painting. A few linear leaves can pull shapes together and integrate contrasts.

Line in flower designs can be actual materials such as stems, leaves, feathery parts of foliage or flower or background lines such as window frames, table edges, accessories and lines created by edges of contrasting values.

Repetition of shapes, colors, textures, sizes and voids can also suggest visual paths or lines. All these can be continuous or broken; all may be real or imagined. They must seem to lead to an area of the painting and have a purpose even though they are broken.

The directions of lines tend to suggest the following: vertical for strength, horizontal for quiet, oblique for movement. They can be long or short, curved or straight, weak or strong, thin or thick, delicate or bold. However, one characteristic should be dominant in a painting. Always work for unity, harmony and variety.

SHAPES

"I see in Nature the cylinder, the sphere, the cone, putting everything in proper perspective, so that each side of an object or a plane is directed toward a central point. Lines parallel to the horizon give breadth, that is a section of Nature. Lines perpendicular to the horizon give depth. But Nature, for us men, is more depth than surface, whence the necessity of introducing in our vibrations of light-represented reds and yellows—a sufficient quantity of blue to give the feeling of air." —Cézanne to Bernard in 1904.

An artist looks at a landscape, and sees buildings, mountains, trees and flowers, but he thinks of them as shapes. He thinks of how he can group those shapes, and how many he can omit. He looks for shapes that are repeated, and those which contrast. He may see cone-shaped flowers repeated in cone-shaped distant mountains, shapes that go from large to small, sharp to hazy, clear to diffused.

In that brief paragraph Cézanne spoke of lines, colors, shapes, surface, space and light. He spoke of shapes in nature as the cylinder, the sphere, and the cone. In flowers, we can find these basic shapes and combinations of them. The artist may see these shapes as flat, two-dimensional, or rounded by light and shadow as three-dimensional forms. Flowers themselves have definite forms. The painter can try to capture the spirit of the form and rhythm of the flowers. A circular or oval shape is restful and passive; a complete circle is boring; squares are monotonous. Rectangles are more interesting to the eye; triangles suggest stability with broad foundations. A tall, thin shape becomes a vertical; a low, long shape becomes a horizontal; a portion of a circle becomes a crescent or fan. A cone shape is a combination of circle and triangle.

In flowers, as in all living things, there is movement. Living organisms and flowers are best expressed with curving lines. Flowers and foliage are in constant movement—blowing, lifting to the sun, bending with the rain, and dying. These movements distort and vary the basic shapes. They create rhythms. Evenly-spaced petals can overlap, twist, turn, and create irregular patterns. A flower and buds grow from a stem and blow either north or south from the center of the flower facing the sun.

Shapes suggested by flowers may be geometric, or those of balls, cups, hearts or wheels. *Ball* or *sphere* shapes are suggested by large chrysanthemums, unopened roses, double buttercups, and buds of many types. *Cup* or *cone* shapes suggest tulips, petunias, morning glories, lilies, jonquils, begonias, gladiolas and columbine. *Wheel* or *circle* shapes are suggested by single-row petals, single-row anemones, daisies, cosmos, asters, chrysanthemums, roses, pansies, mallows or sunflowers.

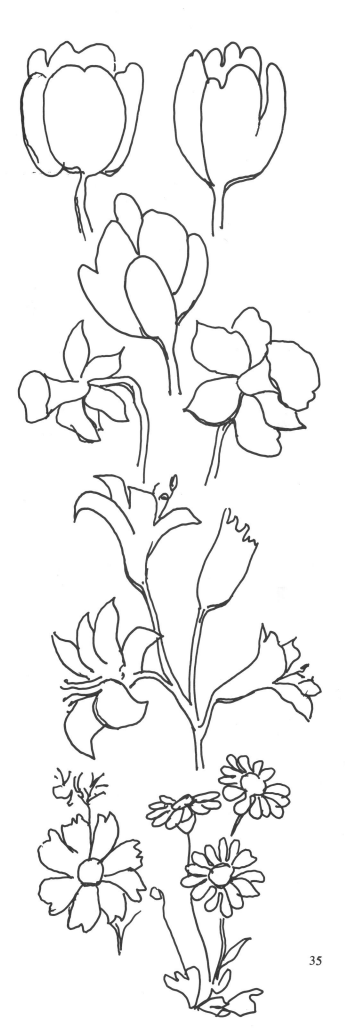

35

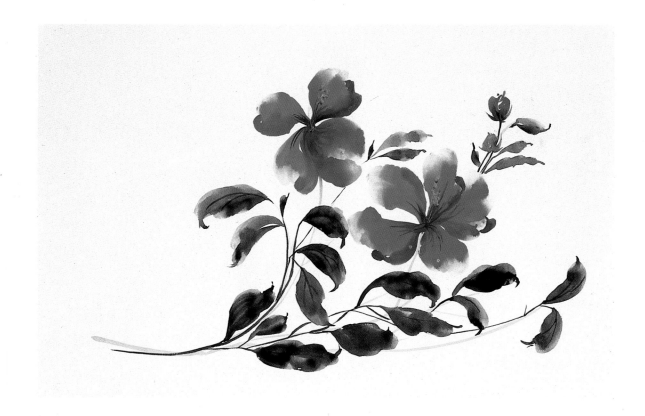

As flowers are suggested by shapes, so are the leaves or foliage of plants. Leaf shapes are classified by shapes related to geometry, by botanical descriptions, and by names of related common shapes such as heart, sword, feather, cone, and ball. These leaf shapes have definite structure and identity as to arrangement within the shapes, color, and texture. Artists who explore foliage learn to mix greens in many ways, and to create the shapes with brush strokes and other techniques.

Shape, to the artist, usually refers to the contour or two-dimensional shape. Persian illustrators created jewel-like miniatures with tiny, flat shapes. Japanese print-makers like Hokusai and Hiroshige perfected simplified shapes stripped to their essence.

Dutch painters Cuyp, Brueghel and Ruisdael and English artists Wilson, Crome, and Constable suggested deep space with illusions of solidity. Poussin suggested the illusion of piled-up masses, with shapes. Turner melted the shapes of objects in a rosy haze, in the mists of dawn or sunsets. French artists of the late 19th and early 20th centuries blurred the edges of shapes with quivering light. Expressionists like Van Gogh twisted shapes of nature to express the turmoil of his feelings. Gauguin outlined

shapes set off in areas of color for emphasis. Paintings of the primitives, masters of East and West, traditionalists and modernists, can be studied for shapes. A good exercise is to place a sheet of transparent paper over a reproduction of a favorite picture and trace the shapes, to see how the artist created the shapes of his composition.

In design, the geometric shape is not as interesting to me as the distorted or stylized shape. In a stylized shape, or a shape in nature, there are more irregularities, more variations, more changes in direction, more variations in the edges. The character of a shape can be expressed in the curves and angles, in the quality of the edges, from rough to smooth, hard to lost, blurry to clear, jagged, prickly or soft, etc. Shapes can be combined, overlapped, interlocked and used in contrast to line, color, and texture. They can be placed to give gradation or strong movement, and to connect movements or give unity. Shapes can be modelled in light and shade to create form or the illusion of a third-dimension depth. Shapes close in value can pull elements together. Shapes repeated can create rhythm and pattern. They can be repeated at rhythmically spaced or regular intervals, and in different positions.

CHAPTER 4

DESIGN AND COMPOSITION

In our great universities and schools, the student of art is required to take many courses of study called Design. Many of these courses are prerequisite to painting, sculpture, ceramics, enamelling, weaving, architecture, printmaking and other arts.

According to Webster's Dictionary, *Design* is to fashion according to a plan, to sketch a pattern, or the arrangement of details to make up a work of art. Again, according to Webster, *Composition* is the art or practice of so combining the parts of a work of art as to produce a harmonious whole.

I think of design and composition as both dealing with the basic elements of painting. Certainly the principles of dominance, harmony, unity, balance, and variety apply to both design and composition.

In my training, design was basic in learning how to organize the elements of line, shape, color, texture and space for all the art forms. Composition dealt more with design in painting a picture. The picture could be within a circle, a square, or a rectangle. The objects, figures or flowers were arranged within this framework to achieve a quality of order, balance, harmony and clarity to satisfy the eye and the sense of beauty as a two-dimensional pattern.

There were rules and there were formulas. All through history these have changed with the artists and their styles and ideas. Many Renaissance compositions were symmetrical; that is, with equal distributions on either side of the axis, with the figures placed parallel with, and near to the picture plane. Later, the masses were unequally distributed and the figures were placed on receding planes.

A number of Renaissance artists were great scholars of geometry. Many of their rules for space were calculated mathematically, according to the laws of proportion, such as the Golden Section. My first introduction to this rule was from Xavier Gonzalez, who at that time was a visiting professor at Case Western Reserve University. He was a dynamic teacher and a great believer in the Golden Section plan for establishing a composition. Basically, the Golden Section is a special proportional relationship based on the height of the picture area compared to its width. A number of Master painters, including Velazquez, used this procedure as a basis for some of their compositions.

Many compositions can be satisfying without conforming to rigid rules. Either intuition or the good aesthetic sense and judgement of the artist satisfies the picture's structural needs. In a broad sense the laws of composition are based upon analysis of pictures. Discounting the Golden Section, relatively few pictures are composed strictly from rules. And rules change with the times.

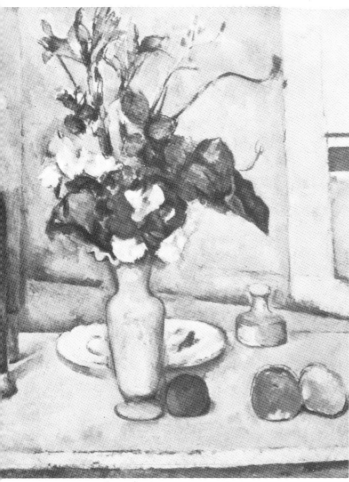

The Blue Vase
Paul Cézanne

The Louvre, Paris

In Full Bloom
Rachel Ruysch (Dutch, 1664-1750)

Akademie der Bildenden
Kunste, Vienna

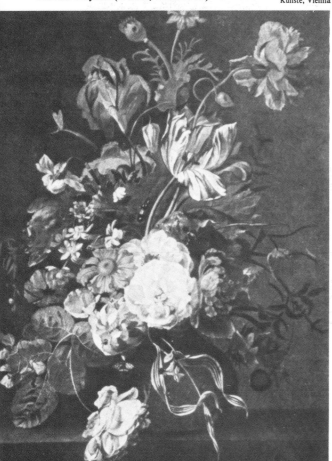

LIGHT

In painting, light is everything! We use light to model forms, to create moods, to show texture, to symbolize the spiritual, to emphasize important areas, to create cast shadows, and to glorify our picture.

Light is used in so many ways—to show movement, to lead the eye, and add interest, contrasts and color. Light can also unify areas and balance dark areas. The use of light and dark shapes to represent lights and shadows implies a light source. Light can come from the sky, as well as directly from the sun or artificial sources. The source can be specific or general. Each type creates different effects.

Shadows, or the absence of direct light can vary in darkness, size and shape to tell us the source of the light and the character of the forms. Shadows on the surface of a flower can show its external and internal contours, the character of its form, and even something about its weight.

Cast shadows give some information about the form blocking the light.

This information can be used to help compose space in a painting. A single source of shadows can be used to create a mood as well as to organize a painting. For instance, a candle flame can create a special mood; the morning sun shining through a kitchen window can create another mood. The shadows of a lovely vase of daisies on the window sill generate yet another kind of visual experience.

Sometimes shadows are painted in cool colors as well as darker ones. This was true in Rembrandt's paintings. He achieved the effect of glowing color in part by warm tonality of the whole painting, and the soft density of his shadows. He used reflections from materials to create the glowing light. Other Dutch paintings of flowers show light and shadows in a similar way.

When light from a single source travels through a room, upon a wall, across the texture of a rug, and over a table as well as beneath it, it creates drama and excitement. Light usually dominates the subject of the paintings.

Light can symbolize the spiritual. In paintings of the 14th century, light was used in haloes to suggest the holy figures and to symbolize sanctity. Gold leaf was used to symbolize light in even earlier periods.

Vermeer used light and dark as he saw them in the painting of the "Officer and Laughing Girl." The source of light is an open window. The light touches

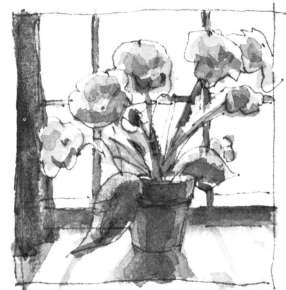

Back lighting

the frame, with the edges outlined by the shadow. The edges of every fold in the officer's dark red coat could be defined, just as the edges and folds of a dark, red rose. Vermeer subtly blends light and dark shadows and half-shadows. We feel the moment. We feel light and air. Edges are neither hard nor fuzzy, but clear. Vermeer paints as he sees light and color; not to dramatize, not merely to show chiaroscuro (Italian for light and dark), but to express reality.

Vermeer's painting of light and shadow differed from that of Manet, who took freedom with light and shadow to create drama. Manet was influenced by the Spanish painter Velazquez, who sometimes used misty backgrounds. Manet simplified light and dark. He reduced the number of shadowed areas and limited the modelling to emphasize the feelings of drama.

I've always been interested in the paintings of Charles Burchfield, who was a student at the Cleveland Art School and a friend of my teacher, Paul Travis. Burchfield used light in his paintings of "Noontime in Late May" to show flowers in all colors, sunny and warm, in patterns of rounded waves, swirling to express joy of the noon sunshine on a day late in May. All forms seem to tilt and move, except for the black fence and the darks in the background which accent or contrast with the waves of growing flowers.

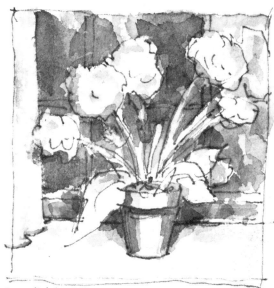

Front lighting

Light from multiple sources can be complicated. Light bounced into shadows is called reflected light. Color can also reflect. The angles of light rays hitting a surface are equal to the reflected angles that bounce into the shadow areas. Some blue of the sky, some green of trees and grass, and some color near a white flower can reflect in the shadows of the white flowers. The degree of reflection depends, of course, on the kind of surface the light strikes.

A shiny surface reflects much more light and color than a dull, absorbent surface.

Shadows from one light source, when that light is placed close, tend to be dark and have little color. As objects are farther away from the light, the shadows seem darkened by the complement of the

Side lighting

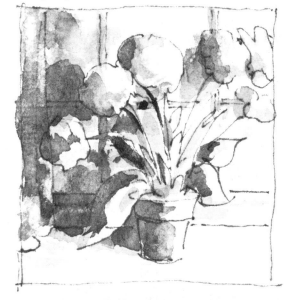

When planning a picture consider the lighting carefully. It is best to keep it simple. Here I have diagrammed three direct lighting situations that are well to keep in mind as you develop your composition.

39

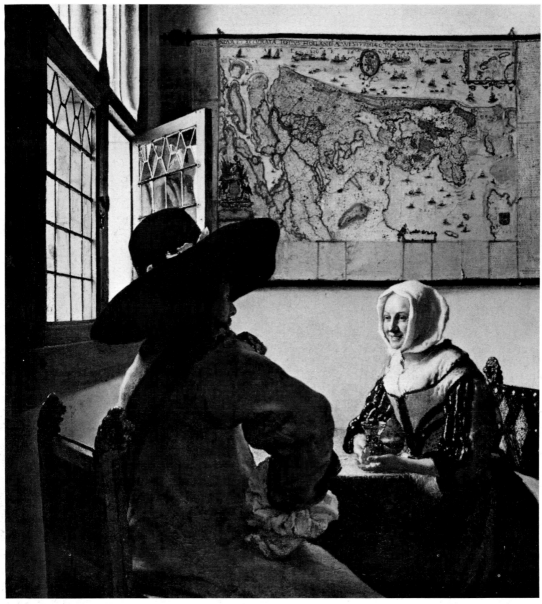

Officer and Laughing Girl
Johannes Vermeer

surrounding color. For instance, a red rose would have the complement green added to its shadow. A yellow marigold with orange-yellow would have cerulean blue or a cooler earth color such as raw sienna in its shadow. Cobalt blue with a touch of alizarin crimson might make a darker shadow. A violet flower would have yellow as its shadow complement. However, since yellow has such a light value, it would make the violet muddy. In cases like this, sometimes a brown or blue could first be used to darken the violet, and then a darker violet could be used.

If there are two light sources, such as the sky and a ceiling or spotlight indoors, the values and the hues will have interesting differences. Sometimes the areas toward a warm light or the sun can be warmer and the shadow sides cooler. Sometimes the color of the sky makes the light side blue, and reflected color makes shadows warmer.

Shadows near us seem darker, cooler and more hard-edged than those far from us. Aerial perspective dulls colors and softens edges. Shadows should not be painted until last. A good procedure is to glaze or wash over the complement of the color to make the shadows and to darken the area. The local colors beneath the shadows change as they go over the grass, over a wall, or over flowers, and the shadows also change as these colors are darkened.

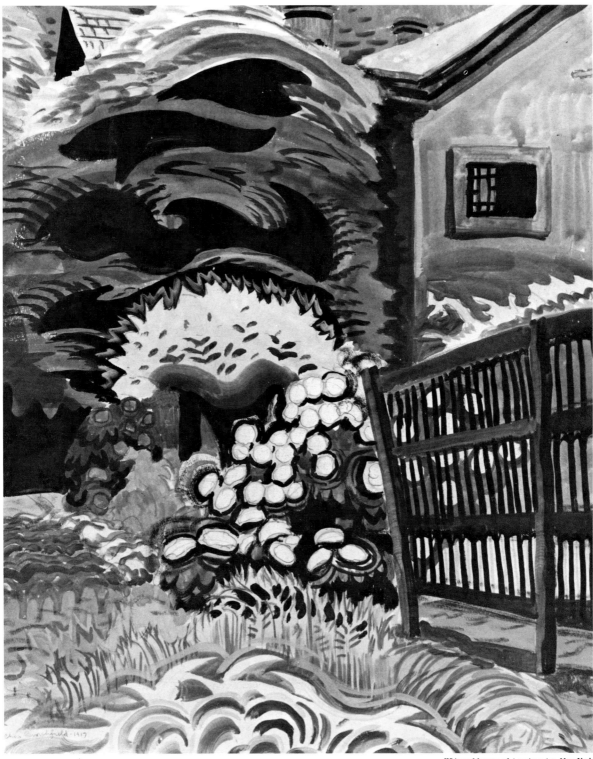

Noontide in Late May
Charles Burchfield

PATTERN

Pattern in flower painting means how lines, shapes, colors and textures relate or vary. This can be the repetition of lines, shapes, colors and textures on a surface such as wallpaper, fabric, or an overall pattern painting. Pattern can also refer to the way of breaking up the painting surface into positive and negative shapes, or the arrangement and balancing of design elements at each step in a painting. In painting pattern can be created by arrangements that relate or are at variance with each other.

In Burchfield's painting "Noontime in Late May," a flowing pattern suggests wind and creates rhythmic movement. Matisse often composed with repeated lines, shapes and colors to create patterns in space. Eye and mind seek relationships such as similarities, contrasts, and sequences to make visual patterns. Some of these patterns are simply made by chance or by nature. A crack in a wall, frost on a window, bark on a tree—all these create patterns.

Patterns can be those created by tie-and-dye or batik; they can be symmetrical, asymmetrical, axial, radial, or rhythmic like music, with themes.

In the placement of flower shapes to make patterns, the number of flowers is dependent on the size of the flower and the composition. "Less is more" is a good rule to follow. A large number of flowers make too busy a design. An uneven number makes a grouping more interesting, and with more graceful design.

Flowers placed near the center or the edge of the painting should be of less importance. You don't want a bull's-eye, nor do you want the eye to leave the paper. Flowers, buds and foliage of the same plant at the same distance should be painted with the same intensity. Again, flowers, buds and foliage at a distance should have less intensity than those closer to the observer.

The pattern of flowers placed in containers should be harmonious with the group and individual flower shapes. For triangular or cone-shaped flowers, a flared or triangular vase might harmonize. For a crescent-shaped flower, an oval or flared container usually works best. For a half-circle, use a flat-footed

or flat container. For circles or ball-shaped flowers, a circular bowl or squatty container is preferable. For an S-shape (Hogarth) arrangement use a cylindrical shape. And for a side-triangle, a low, flat container would work well. Whatever the container, its size, placement, texture, color, material, or surface should fit into the overall pattern. The big, positive shape should be of more importance than the negative shape or pattern.

The imaginary line that roughly bisects the weight of a form or extends up and down through the shape is called the *axis*. An axis need not be a straight line; it can be a line with a long, shallow curve, or a short, sharp curve. Two axis lines in a picture can create a rhythm. They can force a symmetrical pattern, a cross, or interlacing lines, etc.

TEXTURE

Texture has to do with the surface feeling. Is the overall feeling rough or smooth? Are all parts painted with equal feeling of surface? What kind of edges do the irregular shapes of foliage have? What is the feeling of a velvet-like rose petal as compared with the thorny stem? Are light and dark used to give a different feeling of surface?

Variations in textures can be limited to give a painting unity, or they can be used to give a quality of contrast. Different techniques can be used to create different textures.

Textures which differ in surface can be unified by color and shapes to create a composite sensation of texture. Whistler explored line, shape and color, using each one to create texture. Sometimes his textures were soft, sometimes hard; sometimes with strong emphasis on indistinct textures to make a painting seem mysterious. Moods can be evoked with indistinct textures. In addition to composite and indistinct textures there can be contrasts, such as hard or rough placed over smooth or soft.

In flower painting, texture can be used to create an illusion; to make the paint surface itself a real texture, a unifying element, a dominant element in a painting, and to create a mood or sensuous quality.

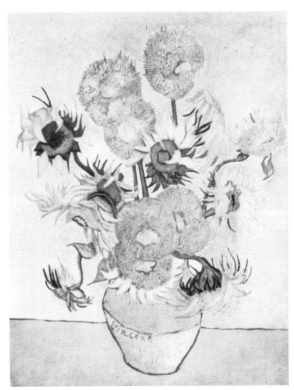

Sunflowers　　　　　　　　　　National Gallery, London
Vincent Van Gogh

The textures have become a most important part of the effectiveness of this painting. Although the texture created by the paint itself cannot be duplicated in watercolor other techniques can be used to create equally desirable textures. See again pages 23 to 29.

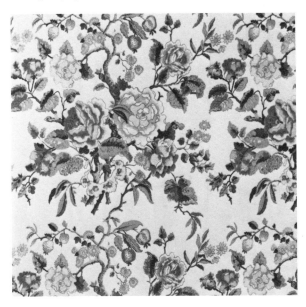

Pattern and textures are closely related. A repeated design such as a flower pattern as used in wallpaper creates a kind of texture. This principle can be quite useful in developing interest in a painting.

43

a Division of space that is too even tends to be static.

b An off-center space division is usually more interesting.

c I often place marks at the centers of sides and top and bottom to help me keep interest areas off-center.

d Try to avoid lines leading to picture corners.

e Work for a variety of shapes both positive and negative.

f Once the general placement is set you must consider the division of the values.

LAYOUT—STRUCTURE

Structure and pattern go hand in hand in composing a painting. Techniques of arrangement used to make order within patterns can be called structure. Structure deals more with the third dimension of form in space, pattern more with the flat break-up of surface.

Structure is the organization of forms in space: proportions, mass, weight of a form, tension and balance of the forms, placement of the observer relative to the scene or painting, grouping in a plane, continuous space, interrupted space, angular perspective, spiral space, plastic arrangement of flowers in space, and relationships between pattern and space.

For proportion—whether it be small, large, massive or delicate flowers—the relation of width to length and proportion of the whole plant are considered. It is a question of measurement.

Structure also has to do with light and dark— how things contrast, show gradual transition, how they model forms and how they create the illusion of depth.

How the contour lines are drawn describes a sense of feeling of a form, how the forms are overlapped, where the most important object or form is placed and how the texture is described—all are techniques of arrangement within a pattern to give structure.

All paintings can be studied for structure. Where is the horizon line? What is the point of view? How much distance is shown?

A painting might start with flowers in the foreground and end with distant hazy mountains. It might lead the viewer back step-by-step into space. This is three dimensional form and space—an illusion of space created by lines, shapes and color on a flat surface.

g Try many roughs to see what will make pleasing arrangements.

h Rough diagrams like this are helpful in working out a value pattern.

Avoid having major forms appear to rest on the picture border.

j When major elements are too centered the background spaces are likely to be monotonous.

SPACE

Space in flower painting can be depicted in a number of ways. Flowers can be painted with or without a background to give the illusion of space. Flowers can diminish in size in relation to distance by becoming smaller as they are painted higher in the picture. Overlapping flower shapes make those on top seem nearer. Relative color value or modeling can give the illusion of roundness or depth. Warm colors seem to come nearer, while cool colors tend to recede. Space can also be created through linear perspective. Space is also created through aerial perspective—distance as seen through layers of air, rain, fog or snow. Edges blur and forms seem indistinct.

Space can move back continuously in a painting or jump from foreground to distant ground, skipping the middle ground. Objects and flowers can be painted flat on the surface as in many designs, without modeling, light or shade.

Pieces of cardboard, sponges and dried foliage can be used to print decorative foliage, blossoms, and rhythmic lines such as stems or leaves over watercolors of flowers. This creates space variations. Space studies can be made in planning a flower painting by using pieces of colored tissue with acrylic medium.

k Off-center placement helps to break up negative space better.

l Off-center with oblique emphasis often makes a dynamic arrangement.

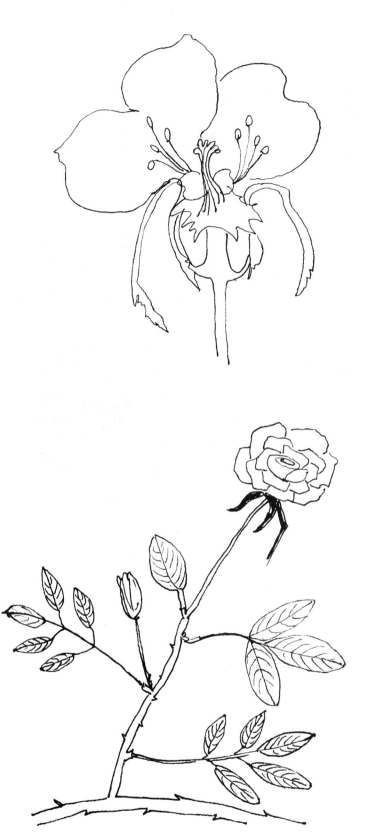

DESIGN & STYLE

Design begins with nature. The best place to start to study design is by observing flowers and plants. Study them—any of them—and learn as much as possible about them. First concentrate on a single flower. Make drawings of the contour, its gesture and with shading in values from light to dark. As you draw, analyze the shapes. Study the flower for the basic overall geometric shape, then examine it to see if it is a combination of shapes. The center of a rose could be a cone, the circling petals could represent a circle · or a ball. Then consider the texture and structure, such as how a leaf grows from a stem, and how the flower is formed. When you learn as much about this subject as possible and have some practice in watercolor techniques, you will be ready to start designing.

Design, styles, mannerisms and ideas constantly change. However, the great masterpieces, both historic and contemporary, have followed certain rules of design which apply to all forms of art. They are ways of putting the basic elements together to create balance, rhythm, opposition, and movement to make a pleasing, harmonious unit.

Once you have a basic knowledge of realism you can take a step away from nature. Shapes can be elongated; proportions can be changed; leaves and blossoms can be eliminated. Remember, however, you must still recognize a rose as a rose and a daisy as a daisy. You can also exaggerate certain characteristics and dramatize scale, lighting and color.

Or design can be *conventional*. This often is exact duplication of the flower design. Textiles, wallpaper and stencil designs on furniture and artifacts often have conventional designs.

A third style is *geometric*. Here we deviate from nature by drawing the flower or plant not with easy,

free-hand curves but with mechanical instruments such as a compass or a straight edge. The design tends to be more mechanical than natural. A flower might be a circle and a stem, a straight line, or part of a circle. A geometric design might be a complex structure of circles, cones, and other geometric shapes broken into different color patterns. The geometric design often suggests bold contrasts of gradation in color and light. Some planes overlap others with a forward and backward movement. This can be done by spacing and lighting.

Abstract style can be quite arbitrary, departing from realism to the extent that only the essence of the motif is suggested and the natural flower is not even recognized.

Flowers are often used in repeat designs for textiles, apparel, furniture covering, draperies, and wallpaper. The original painting or design is known as the "croquis," which is the original design not in repeat. The croquis can be used for laying out plans for dividing the painting, and to repeat in different vertical, horizontal, or more complicated pattern schemes.

Tracing paper, metal rulers, triangles, pencils, charcoal and erasers are used in this process. The design is then transferred to paper for painting. It is often best at first to work rather small. Any medium will do. I have used tempera and I have worked rather large in watercolor.

Repeat designs may be formal or informal. All patterns either way must have some place to start the repeat, both horizontally and vertically. If the motif projects outside the square or the rectangle, it will help to unify the pattern. In floral painting, leaves added to this design could unify the pattern even more.

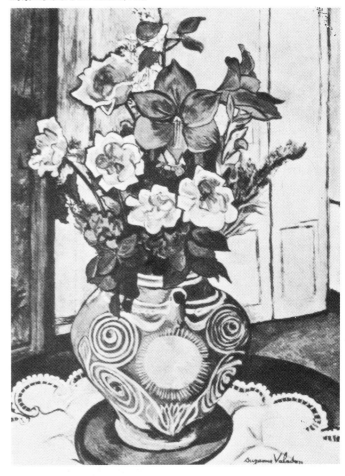

Jug with Flowers
Suzanne Valadon
Approaching her subject primarily with an eye to pattern, the artist emphasized the free-moving, varied shape of the bouquet by (1) placing it against a simple background of lines and planes, (2) contrasting it with the rigid pattern of geometrical curved designs dominating the lower part of the painting. Distortion helps create variety of shapes, stronger rhythms, increased tensions.

a Think of the general shape of the flowers and container in relation to the overall picture space.

b Should it be dark against light or light against dark?

c Think about interesting grouping and using related objects

d Begin to plan a value pattern. Try to control tangents, corners and the break up of space.

e Think about the bigger scene. How much of the room should be shown? How will it be best to have the flowers dominate the environment?

When we begin to sketch, we think design, composition, and how to create order. We think of the placement of the first flower in relation to all sides of the paper. Remember space divisions with more sky than earth or more earth than sky are more varied and interesting than a center division. Also, vertical divisions are more interesting when not in the center. They are less static, more dynamic. Divisions which are level or straight up and down have less movement than obliques. When one end of a distant hill is higher than another, it creates movement. When a vertical slants, it creates movement. A stem bends with a flower. It swings, twists and turns sometimes, creating the same kind of movement.

The first flower could be placed at a spot which is an unequal measure from all four sides. This could be the focal point. Lines, shapes, color and how they are put together should lead the eye to the focal point and through the painting. The first flower should be in proportion to the size of the picture area. For example, the actual size of the narcissus is a good proportion for paper 22 x 15 inches or half a sheet of watercolor paper used vertically. Always consider the size of the flower. Consider whether it will be used in a container, on a table, in a window, in the garden or just in a study without any background.

Think of the shape of your picture. Think of the shape of the whole plant. Even though the actual flower shape is basically a wheel or a circle of six petals around a small circular cup, you can emphasize a strong vertical shape of a petal by twisting and turning the shapes and forms leading the eye from top to bottom. When each flower blows or faces in a different direction, we see the overall flower shape as parts of circles or as ellipses with varied spaces between the petals. We see the leaves as elongated ellipses twisting, turning and dancing. They are seldom rigid.

When you start to paint a flower with petals *look* closely at it. Note that the shapes vary in size and there are differences in the intervals between them. When painting white petals make sure the important

48

f Plan the background and lighting. Start to break up the shapes into interesting values.

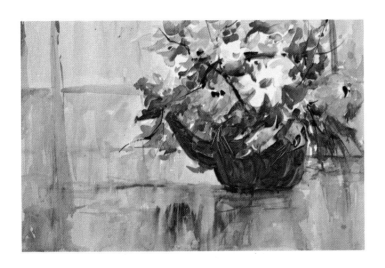

whites are not at the edge of the painting, but placed with gradation so the eye is not led out of the picture.

Always be conscious of your picture borders. Set up basic compositions by considering the space divisions. Plan the flower design to take up at least three-quarters of the picture area. Think of the values in the background. Don't have half background and half flowers. Stretch forms out to the border in two or three places. Avoid negative spaces that detract from the center of interest. Begin with simplified, more or less abstract shapes and work toward the more specific and defined.

Begin with a flower and establish it in a general way. Use this to determine the placement of others. Draw across voids or leaves to establish placement of the second flower. Draw through. Try to keep line flowing.

Study the contour of the flower forms, leaves and stems, and carefully define the character of the flower. Exaggerate the character as necessary. Let the pencil always look for shapes with a flowing kind of feeling. Avoid too many hard edges. Try to show more detail on one side than on the other. Incorporate the flower design with the background. Do not have outlines of all flowers or leaves.

Work to lead the viewer's eye through the composition. Combine masses with line. Add some value changes without changing color. Add some color changes without value changes. When painting into a shadow, have everything more dark than light. Edges away from the light are cooler, front planes are warmer.

Avoid too many outlines. Paint some verticals through horizontals, blot with tissue and re-establish shape.

Following are some general thoughts on the compositions of flowers in circles, verticals or horizontals.

In all compositions, begin with the subject in nature. Flowers are fresh, bright and soft. Flowers follow basic shapes. Some adapt better to circular frames, some to vertical and others to horizontals.

Simplify from nature. Think of expressiveness and relationships. Don't try to copy exactly everything you see; you may want a dark pattern against a lighter background or a light pattern against a dark background. You may want a large light shape and smaller darks, or a large dark and smaller lights in mid-tones. You may even want a gradation or allover pattern. Here are different suggestions to try:

To paint a single flower with foliage or a bouquet of flowers with buds, foliage and stems, think of the big, overall shape. Work for interesting, not static, shapes. A shape with uneven dimensions is likely to be more interesting than a symmetrical one. Interlocking shapes are often effective. Shapes on the oblique have more movement than those that are straight. Vary edges from hard to soft, lost to found, smooth to rough, and link the background so that elements do not look pasted onto the painting. Consider rhythm, color, value changes, direction of the lights, darks and mid-tones. Then within the shapes, design the petals with fresh, bright, soft curves. Accent the focal point with contrasts. Try to lead the eye to the focal point.

Plan some smaller flowers as secondary shapes. Ed Whitney speaks of shapes as papa, mama and baby shapes. Robert Laessig speaks of them as quarters, dimes and nickels. The papa or quarter shapes are the largest and most important—such as the host; the others less important—such as guests or secondary shapes. They should vary in size, be placed with spaces between them, or overlapped. They should not all face the same way. Stems, foliage, patterns of light, patterns of darks and textures can give unity. Repetition can give unity. Dominance of one color and one shape can give unity. Most important are harmony and expressiveness.

STILL LIFE & INTERIOR FLOWER ARRANGEMENTS

"Less is more" in all Chinese painting. Flowers are often painted without preliminary drawing and without background. The artist begins from the heart of the flower and executes with sure, rhythmic, flowing brush strokes a single flower with perhaps a bud and a little foliage. Usually not even a container is included. There is much to be learned from such simplicity. Why say more when less says it better? There are artists who dislike any formal flower arrangement and detest the complicated and crowded ones. I like the arrangements that look natural with not too much crowding. So often a painter will forget to leave breathing spaces. When painting trees, Jack Pellew likes to leave spaces for the birds of different sizes, thinking this way helps you avoid creating a solid, airless tree. The same is applicable to flowers, where the spaces could be used for bees!

It helps to place the largest flower first and then relate other flowers and materials just as in any design.

When you have made an arrangement that pleases you, try some small sketches in proportion to the paper size you plan to use for the painting. Think of the dominance in line, color, shape and texture of your flowers. Work out a theme of curves, shapes and value contrast. Plan the values carefully. Have the lightest value and the darkest contrast at the most important place. Plan patterns of light and dark, patterns of color, and directions of lines either with foliage or shapes or colors.

a

b

c

d

e

a Container too large and too centered.

b Static because elements are too balanced and too evenly
 spaced between each other and the borders.

c This is better. Note variety of shapes and spaces
 between them. Value contrast makes container too
 important.

d Good variety of shapes and placement. Some forms
 overlapped, others not.

e Too static. Everything too much the same size and all
 are overlapping each other.

Flower arrangements should be kept
simple with the emphasis clearly identified
with a geometric shape. As diagramed here
the basic shapes are (1) the S-curve, (2)
vertical, (3) circular, (4) and (5) triangular.

1

2

3

4

5

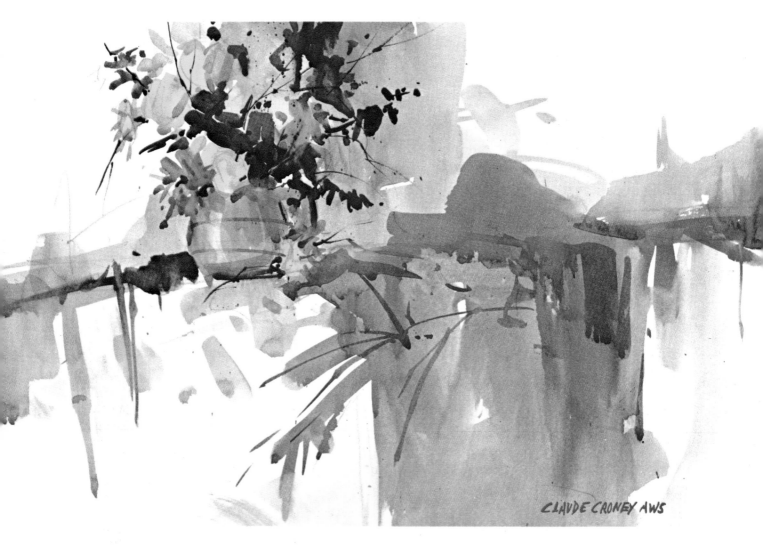

CLAUDE CRONEY AWS

Check the overall shape of the arrangement and smaller shapes within the whole. Determine the light source and how the shadows fall. Remember that under most lighting conditions shadows are rhythmic and usually not parallel; they emerge from one spot and are darker near the object, fuzzier or less distinct farther away from the object.

Consider the use of such things as bottles for tall shapes, flat plates or bowls for low shapes and round fruit or vegetables for variations. Some shapes and forms should overlap, some separate. When your design, pattern and form description are ready then paint your picture without trying to copy your planning sketches. Try to get the general character and the essence of the planned arrangement, but don't let your preliminary work limit your creative feeling.

In an advanced class with Van Duzer, students were told not to copy and not to think of the positive shapes or forms of a flower arrangement, but to first paint the negative spaces and then the essence of the flower. This approach has much merit.

Start drawing flowers with simple geometric shapes. Think 3-D. Exaggerate the swirling lines. Then when you paint, exaggerate the color to express the essence.

Check for balance in design at each step.

The Vignette

The vignette is a picture that is not completely painted to all borders. The remaining white spaces or shapes left over can give a dramatic quality to the design of the overall painting.

In this painting by Claude Croney the bold cross shape of the composition creates strong impact. The flowers dominate as the center of interest and are nicely balanced by the darker green shape below it. The unfinished negative areas at all corners allow full concentration on the colorful bouquet.

Except for the center of interest, very little in the picture is defined. Much is left to the imagination of the observer to supply whatever answers we wish. This is a fine example of less is more.

CHAPTER 5

COLOR

Of all the visual elements of painting, color is of the most importance in painting flowers. It is color which makes the most immediate impression, the element to which we respond most directly.

Technically, color is a sensation in the eye and mind caused by *light*. Different colors have different wave-lengths and frequencies of light. Pure colors of the visible spectrum, seen by passing white light through a prism, go from red—with a long wave and low frequency, to violet—with a short wave and high frequency. We see these colors in the rainbow, and learn in science that they range from red to orange, yellow, green, blue, indigo to violet. We say R O Y (Roy) G B I V or (G biv). When all colors of light are mixed, white light results.

In painting, our colors are pigments in forms of pastels, watercolors, oils, acrylics, etc. Three of these pigments are necessary to produce the illusion of the other colors we see in the rainbow. These three primaries are red, yellow and blue. When we mix these pigments together in equal amounts, we produce black.

To describe color in painting (in pigments), we speak of three properties of color; *hue* (the name of the color), *value* (lightness to darkness), and *intensity* or saturation (its purity or the amount of gray in it).

Scientists have made charts for the study of color and color-mixing. I have one notebook from my art school studies filled with notes about color alone.

The way we react to color is complicated. Our perception of color is influenced by many factors. Colors are affected by the colors around them.

Complementary colors—colors opposite each other on the color wheel—interact in one way. Related colors—those near each other on the color wheel—interact in another way. The manner in which color is applied—such as transparent washes, thick paint, textured paint, dots of paint, lines of paint, planes of color, as well as the kinds of paint used—causes many different results. Colors may also be classified as *warm*—(red, yellow, orange); and *cool*—(green, blue and violet). The warmth or coolness of a color is always relative to the conditions under which it is seen. Also, colors may seem to advance, recede, or fluctuate. They may be symbolic or associated with ideas. Colors can be used to express feelings, moods, kind of day, seasons.

Then there are color schemes:

1 Monochromatic: containing value and chromatic variations in one hue.

2 Complementary: value and chromatic variations of two hues which are positioned opposite each other on the color wheel.

3 Analogous: neighboring colors, containing value and chromatic variations of neighboring colors contained within a segment no larger than one-third of the color wheel.

4 Triad: containing value and chromatic variations of three hues, located equidistant one-third of the circumference from each on the wheel.

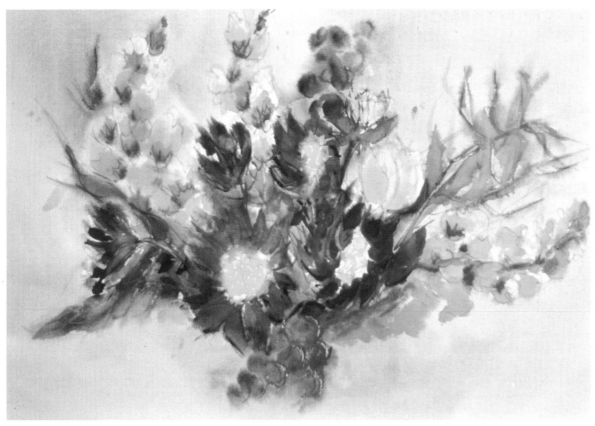

Other schemes are more complicated. One of the best is painting with a special flower in mind. Include all of the hues, values and gradations from pure color to grayed color you can think of when you look at the flower and its foliage, then, all the hues, values and intensities you want to express in capturing the essence of the subject. Choose the colors you like; brush them on the paper; keep them bright, fresh and clear.

After your experiments with pure colors, try combining some of those you saw as pure colors. Have you created new hues, or have you grayed the colors? Mixing these colors can change the hues, values and intensities (brightness to dullness). The amount of water and pigment used adds immeasurably to these variations. Colors can also give a feeling of movement, and this can be done in these experiments through gradations of value, intensity of repetition of color.

Colors are affected by colors near them. In color schemes and experiments, try painting colors to give warmth and suggest flowers that are reds, yellows and orange colors on a neutral background. Make another with cool colors, such as green, blue and violet on a neutral background. Choose colors having contrasts in value and intensity. Make a third experiment with both warm and cool colors, with either warm or cool dominating against a neutral background.

Look at a flower, a plant, a flower bouquet, a vase of flowers or a section of a flower garden. Then try to spot or drop colors on paper just as you see them, without drawing. Think color. Use pure color or variations in hue, value and intensity. Work on dry paper, then on wet paper, but think only of color.

For a much deeper study, you might read *The Interaction of Color* by Josef Albers; the Yale University Press. I believe that it was the year of his 75th birthday, when he was "just becoming to understand a little about color." Another excellent book is by Tom Hill entitled *Color for the Watercolor Painter,* published by Watson Guptill.

In 1824, when artists competed at the official

Salon in Paris, color was represented by two artists in quite different ways. One was Jean Dominique Ingres a follower of Raphael and the painters of Florence, honored for their beauty of line. The other was Eugene Delacroix who was inspired by Titian and Rubens, all of whom were scorned for their tumults of color.

Delacroix died in 1863, but he left for artists a "Dictionary of Art." There he wrote his discoveries about color. "In Nature," he said, "we seldom see an unbroken line. The dance of light along an edge makes it seem to quiver and waver . . . Flecks of contrasting color placed side by side," he observed, "because of their effect upon the eye, [create] the brilliance of shimmering light . . . The touch of the artist, left visible in his brush strokes, record feelings. Near and far planes or volume could be modeled without light, shade,perspective, only with thick and thin strokes of color . . ."

Delacroix likened his feelings about colors to the effect of music upon the senses. He called this the abstract or musical quality of color, especially when he stood afar, so as not to recognize objects but to sense their color.

The Impressionists learned from Delacroix how to paint with quivering light, how to paint with strokes of color, and how to free color from line. Light quivers in flecks of color. In this shimmering light, edges are lost and forms seem to melt away. Neither line nor form is seen before color. The Impressionists, with their broken outlines and flickering flecks of color, led the way for the artists with still more freedom and more daring color—such as Raoul Dufy, Matisse, Derain and Vlaminck. They were called the wild beasts (Fauves) because, for them, the world exploded with color.

New ways with color continued until the point where color was no longer used to represent an object but to speak directly to the senses, as in the paintings of Kandinsky.

Victor Lowenfeld, author of many books on creativity, once made these perceptive comments: "In

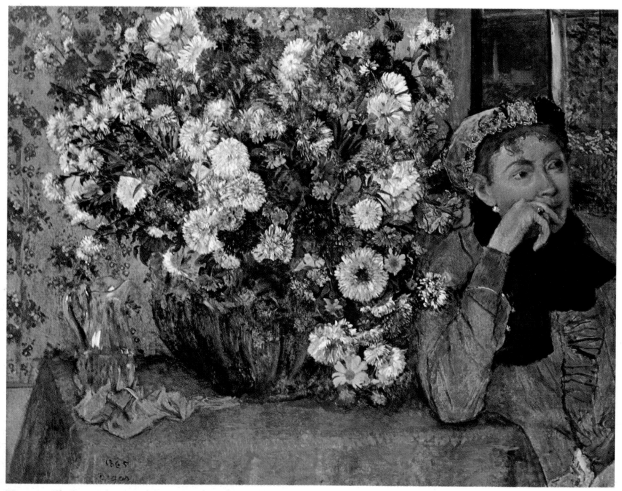

Woman with Crysanthemums
Edgar Degas

the representative arts we do not deal with the different time sequences as we do in music. We can see the whole picture simultaneously. In color, however, we can draw close parallels with music if we regard the single colors as tones, and a color harmony as a chord. In a picture, as in music, the resounding of a color harmony can be interrupted by colors which are interrelated in order to increase the tension for the resounding color harmony. In the same way that rhythm is produced in music by repetition, it is also produced in color. In music as well as in color compositions the interest in repetitions is increased by varying them, either by different emphasis with regard to the intensity of tones (dynamics), or through different intervals (harmonies)."

Painting flowers in watercolor can take many schemes and techniques of color and can vary with the kind of painting you wish to express, from realistic to stylized, from conventional to abstract. Color can be painted in an impressionistic or bold style, or it can be tightly controlled. It should be an individual expres-

sion, and the colors should be fresh—like flowers.

Painting white flowers, think of white against a background and with reflected color. White in light is all colors. In watercolors, white is the white of the paper or white from a tube. However, as with all things in nature, flowers are never pure white because of the sky overhead and the surrounding colors of outdoors, or the colors indoors with light, shade, and reflected colors. Even a white flower against a white background would have color and tone, depending on which of the two whites is darker or lighter. One white would probably be warmer than the other. The warm and cool differences also apply to flowers in red, yellow and orange.

Again, Lowenfeld said it well: "Everything depends upon the meaning of color with regard to its environment. Bright colors may become dull when overpowered by environmental influences. Bright colors may no more seem bright but monotonous when repeated by equally intensive colors . . . Visually bright colors do not necessarily refer to emotional

contents of the same meaning. Colors receive their emotional content through relationships in which they are represented. Since these relationships are an outcome of subjective experiences and associations, color relationships in expressionistic art are highly individual.''

Red to pink flowers are species of rose, tulip, hollyhock, anemone, columbine, aster, daisy, poppy, bleeding heart, lily, coral bell, mallow, iris, bee-balm, peony, phlox, snapdragon, begonia, chrysan-themum, morning glory, cosmos, trumpet flower, carnation, foxglove, geranium, gloxinia, petunia, portulaca, cineraria, marigold, bougainvillea, cycla-men, fuchsia, impatiens, Christmas cactus, hibiscus, poinsettia and many others.

Some reds in watercolor are best for darks and others for lights. Deep reds can be made by adding more pigment or a touch of blue or green. Lighter reds can be achieved by less pigment, more water, a touch of yellow, or a touch of Chinese white. Alizarin crimson, rose madder genuine, cadmium red, or scarlet vermilion are some of the reds I experiment with, but the ones I use regularly are alizarin crimson and cadmium red.

Yellow flowers are species of the following: amaryllis, hibiscus, marguerite, chrysanthemum, lily, crocus, jasmine, daffodil, narcissus, primrose, rose, petunia, nasturtium, tulip, snapdragon, daisy, poppy, calendula, aster, coreopsis, cosmos, dahlia, marigold, sunflower, zinnia, lupine, pansy, por-tulaca, adonis, columbine, iris, and others.

Yellows can range from lemon yellows to cad-mium yellows. Cadmium yellows are different shades of sulphide of cadmium. Aurora yellow, which I have on my palette, is sulphide of cadmium. I also have Indian yellow, which is arylamide yellow. Winsor yellow is arylamide yellow. Yellows can be changed with yellow ochre, raw sienna, gamboge or New gamboge. New gamboge is a blend of arylamide yellow and toluidine red. It is not as transparent as gamboge, but has a brighter undertone and is perma-nent. Burnt sienna can also be used to change the value and tone of yellows. Violet can be used, but you'd do well to experiment before using it.

Mountain Phlox Collection of Mr. & Mrs. Clyde Patten

Blue to purple flowers include the following: anemone, columbine, aster, canterbury bell, mountain bluet, delphinium, globe thistle, gentian, iris, true lavender, flax, lupine, blue lily-turf, forget-me-not, cupflower, phlox, balloon flower, spiderwort, pansy, ageratum, daisy, cornflower, larkspur, morning glory, foxglove, heliotrope, sweet pea, lobelia, cineraria, wishbone flower, blue-lace, squill, violet, passionflower, hyacinth, sage, and crocus.

In pigments for the above, I have ultramarine blue, cobalt blue, thalo blue, and sometimes Prussian blue and cerulean blue on my palette. Real ultramarine blue comes from the extract of lapis lazuli. Ultramarine blue mixed with alizarin crimson makes a lovely violet. Cobalt is the middle blue and is often used in flower painting. Cobalt also makes good shadows. The thalo blues are colder. A touch goes a long way. Prussian blue is not quite as powerful as thalo blue, and is sometimes called Chinese blue. The blue that comes from the little dishes from China is beautiful. Cerulean is a good blue but more opaque. But sometimes you want that very opaque blue.

White flowers are usually a species of the following; narcissus, dogwood, iris, tulip, rose, daisy, chrysanthemum, crocus, hyacinth, lily, violet, snowdrop, daffodil, pansy, hollyhock, snapdragon, poppy, begonia, aster, larkspur, morning glory, sweet william, carnation, foxglove, baby's breath, candytuft, impatiens, sweet pea, mallow, lobelia, sweet alyssum, lupine, stock, geranium, petunia, phlox, primrose, and zinnia.

Foliage colors can range from warm to cool greens, yellow browns to dark browns. On my palette I sometimes keep one green, sometimes none. The one tube of green might be Hooker's green (dark), Winsor or thalo green, viridian or sap green. If I do not have a green on my palette, I usually mix cadmium yellow and thalo blue for a base green. I change the tube green or base green by adding yellow or an earth color to vary the hue. I make it darker by adding more pigment or a red.

Some artists experiment with colors by testing them on pieces of watercolor paper in direct sunlight to learn how permanent or durable they are. Manufac-

turers also test their colors and list them as to whether they are transparent, semi-transparent, durable, fugitive, or poisonous if used unconventionally (if you put the brush in your mouth to point it). Some colors are given an original name and a secondary name, such as "Winsor blue" or "thalo" for short.

Here is a list grouping pigments according to their relative transparency. Of course, all these colors are transparent if used with enough water and applied in light washes.

Transparent: (Blends immediately)
Alizarin Crimson
Gamboge
Hooker's Green
Indian Yellow
Lemon Yellow
Mauve
Rose Madder
Thalo Blue
Viridian

Opaque:
(Does not run as freely)
Cadmium Orange
Cadmium Red
Cadmium Yellow
Cerulean Blue
Cobalt Blue
Cobalt Violet
Davy's Gray
English Red
Indian Red
Naples Yellow
Vermilion
Yellow Ochre

Semi-Transparent:
Emerald Green
French Ultramarine Blue
Ivory Black
Manganese Blue
Payne's Gray
Sepia
Siennas
Umbers

"Key" is a term often used in speaking of color. It is a musical term used to indicate relationships of tone, expressive of lightness and delicacy, certain restraint, and muted somber qualities. In color, key deals with the value—its relative lightness or darkness. Value scales have numerous gradations running between white and black. I think of the scale as going from white, high light, light, light light, medium, medium dark, dark, light dark to black. Colors arranged in a modular system with full strength of color at a place on the value scale range from yellow as the lightest in value, red, green and blue in the middle, and violet to black as the darkest. Red, blue and green can be changed in value much more than yellow. Red can be changed in value by making it a very pale pink or a deep dark red, and still hold its color identity. Blue, green and violet can also be made lighter and darker in value, all the way from light light to dark dark.

High key color schemes could be limited roughly to the upper third of the value scale, from white to high light to low light. The intermediate key would include the middle third of the scale from low light to high dark. Low key, the lower third high dark to black.

There can also be two value themes, grouping one set in high key, and the other in intermediate and low key. It is best to let one theme dominate.

Another way of combining colors is to express the seasons. For instance, spring foliage could be expressed with greens made by mixing cadmium lemon yellow, New gamboge and cerulean blue. Summer greens could be mixed with sap greens, Hooker's green light and dark. Autumn greens could be burnt sienna, raw sienna, New gamboge, brown madder and a touch of vermilion or cadmium red. Winter greens could be burnt sienna, ultramarine blue or thalo blue and thalo green with a touch of alizarin crimson.

CHAPTER 6

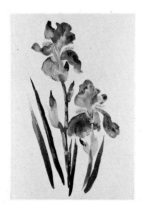

PAINTING FROM NATURE

That is best that lieth nearest
Shape thou to thy work
—Browning

It has been said that the inspiration for all art work comes from nature. I agree.

For me, that which is nearest and dearest in nature is the flower. In our fields and gardens, our markets and homes, and in our hearts and memories—are flowers. We need not go far to find flowers to study and paint. We can have them in all seasons, indoors and outdoors—everywhere.

All through history, artists have tried to capture the essence and beauty of flowers and gardens, from the humblest wildflowers in the countryside to the regal lilies and rare, exotic varieties grown in solariums. This is not a history of flower painting, but a book of flower studies, and so I will refer only to two artists who expressed the art of their times.

Artists speak of their times, sometimes well and sometimes not. But those who speak best are remembered. Leonardo da Vinci spoke as a philosopher, poet, scientist and artist in a world where creative intelligence was considered as highest in the social order. I can remember my professor of aesthetics speaking of Leonardo and his philosopher contemporaries as being the inner circle, with businessmen in the outer circle. My respect for these scholars, poets and artists made me want to study medicine and art.

Leonardo da Vinci's achievements in the 15th century were dazzling. He was one of the pioneers of the biological approach to drawing and painting, the essence of which is scrutiny of the parts of living things, their working and growing. To him, vision was the important means for understanding his world, drawing and painting the most effective and important means for describing and revealing nature's harmony and order. He had a razor-keen observation of nature, creating beautiful forms that seemed to move and live in a world of air, light and shadow.

In the 19th and early 20th centuries in France, those who spoke best were the Impressionists and Post Impressionists: Manet, Monet, Renoir, Pissarro, Cézanne, Van Gogh and Gauguin.

"When I look at one of Monet's pictures, I always know which way to turn my parasol." So said Berthe Morisot, a contemporary Impressionist painter of Monet's time.

Monet not only captured light and color; he worked from nature. He tried to learn as much as he could about botany—all about plants, how they grew, and how they were structured. He consulted with friends and professional botanists, and read horticultural reviews. His garden in Giverny was the main concern of both his life and his art. For years Monet developed his garden with only the help of his family. As the

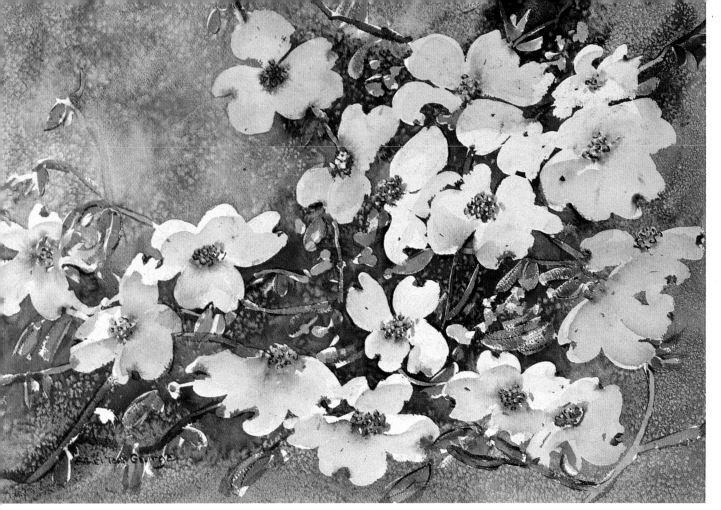

Dogwood

garden became more complex and he more wealthy, he hired a head gardener and five assistants. Monet's gardens, now restored, tell us much about him and how his creative mind used nature as the basis for art.

And what about our own age? Art today is more varied, more complicated and harder to understand. Today things seem chaotic, fragmented, without form or content. It seems to me we can learn best from the past—and from nature. We can study our subject—flowers—just as the figure painter studies the human form to know where arms and legs are placed, their size in relation to the body, how they bend, stretch and move. So we can study the flower to know how it grows, whether from a seed or a bulb, how its roots are formed, how the stems and stalks stretch toward the light. We can learn how the calyx or outer leaves hold the corolla or the petals of a flower, what the parts inside the flower are like; about the pistils, stamens, anthers; and how the leaves grow from the stems.

It would be helpful for the artist to know buds, flowers, stems and foliage of individual plants which belong together. A rose with the foliage of a daffodil would be ridiculous. Even so, individual flowers of the same species can differ, just as people differ. In a given variety, however, a six-petalled flower still has six petals all over the world.

STEP-BY-STEP DEMONSTRATIONS

Delphinium

Subject. The delphinium is one of my favorite flowers because of its beautiful blue color. It is a perennial and there are different species. Some grow tall, spirelike, and are usually blue, but may be lavender, purple or even pink. Some have massive spikes composed of 2 to 3-inch flowers with a single or double ring of petals. Many have contrasting centers called "bees." The Chinese and Siberian varieties do not grow as tall as others. They grow about 12 to 18 inches high and have flowers an inch or a little more in width. They are usually blue or white. The buds and flowers have a little spur, five petals and a cluster in the center. The foliage is fern-like or with deeply divided leaves. The flowers are soft, bright and fresh.

Materials. This painting was done on a quarter sheet of Fabriano, 140 lb. cold press 15 x 11 inches. Its vertical shape was suggested by the spirelike shape of the plant. I did not stretch the paper and it was not necessary to fasten it to the board in any way since my plan was to work small, step-by-step.

Continued on Page 63

61

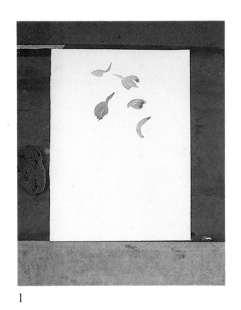

1

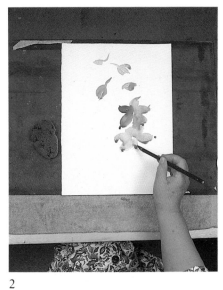

2

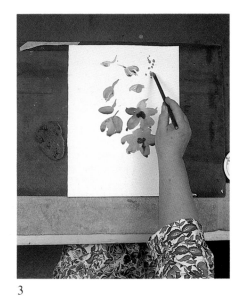

3

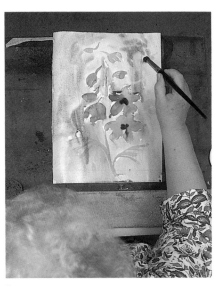

4

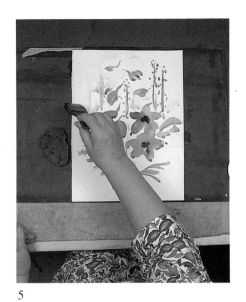

5

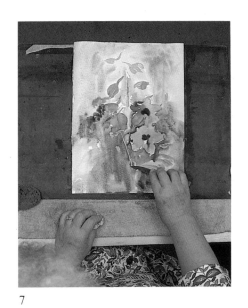

6

7

1 I started this delphinium painting by placing the three flowers and five buds. The first washes were of blue and a little alizarin crimson.

2 A wash mixture of cadmium yellow pale and cerulean blue was added to suggest distant shapes. Other washes were brushed on to suggest distant spirelike shapes. Some of these washes blended with the blue flower shapes to cause variations in the flower edges and to lose some edges into the background. Some of the flower shapes blended into the background. I tried to work rapidly and to keep the painting fresh and spontaneous. I wanted the shadow areas darker near the flowers to give more contrast, but in the distance I sought to keep a medium to pale blue to green suggestion of stems, seed pods and buds.

3 The fern-like foliage was painted in brushstrokes to show some definite form, but most of the foliage was indefinite and allowed to blur.

4 The centers of flowers were made darker to suggest a cluster or contrasting center.

5 Sometimes I mix greens with different warm colors and different blues. Try gamboge or New gamboge with thalo blue. Add a touch of a red to warm the color. Experiment with mixtures of earth colors to change greens. I sprayed a fine mist of water over the painting, concentrating on the background to lose any hard edges. While the paper was still damp but not shiny wet, I lifted a few stem lines with a palette knife and blotted some background with a sponge.

6 By now I have worked out to all corners and I work some wet-in-wet texture over the yellow-green areas.

7 With a knife I scratch in some needed lines on the stems. The paper is still quite moist. A little more definition is suggested in the background.

My palette consisted of almost all my blues—from ultramarine, cobalt, thalo to cerulean blue; a touch of alizarin crimson to ultramarine blue for a violet; cadmium yellow pale; thalo green and cadmium yellow mixed with thalo blue; and a touch of alizarin crimson.

I used #14, series 7 Winsor & Newton round sable for almost all of the painting. I used a second brush with clean water, not too wet to carry some of the color off in gradation. A wide, soft 2-inch brush was used for some background glazing. Washes of all the colors were mixed in little china saucers before I started the painting. These were for the lightest values.

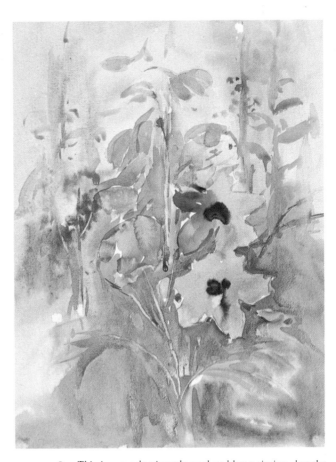

8 This is a predominantly cool or blue painting, but the touches of alizarin in tints add to transparency of the delicate petals and suggest light coming through the painting.

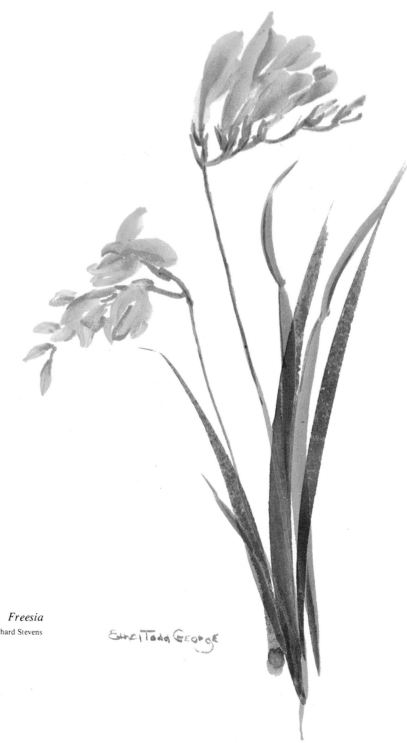

Freesia
Collection of Mr. & Mrs. Richard Stevens

Ethel Todd George

Subject. Landscape with large sky and small foreground field of daisies. Distant trees at horizon. Daisies near foreground more in detail. Distant daisies reflect some of the sky color.

Materials. I used Arches 140 lb. cold press 15 x 22 inches. The paper was stretched and held on a Boga Board.

My palette consisted of yellow ochre, Payne's gray, cerulean blue, raw sienna, sap green, raw umber, cadmium yellow, cadmium orange, burnt sienna and a touch of alizarin crimson to darken the greens.

The brushes I used were a 2-inch soft flat brush and both the #14 round sable and a small Chinese bamboo brush. I also used a palette knife, an old worn bristle brush and a toothbrush. My plan was to have the sky in gradations of gray-blue to a warmer sunnier sky at the horizon, to have distant trees fade into the sky with a few straggly ones done in delicate brush strokes. I planned to have the distant daisies blend in with the grass, with nearer ones more detailed. I planned to have the darkest grass against the whitest daisies and the warm centers more distinct in the nearer daisies.

Procedure. The last details were a few strokes of calligraphy to suggest the pine trees in the distance. I tried not to make these too dark but to use a blue-gray mixture which would look distant. Some calligraphy strokes were added for grass which overlapped the daisies in the foreground and pulled the colors together, to give unity while creating more interesting edges and distance.

There are so many distinctive leaf shapes and forms it is well to study them separately. Some of the best ways to suggest leaves in painting are with calligraphic-like strokes. Not all, of course, can be done this way, but enough can to make their practice worthwhile. Many of the linear leaves and stems can be effective done with a loaded round brush. First lightly touch the point of the brush to the paper and in either a pulling or pushing stroke, quickly go from light to heavy, to light pressure on the brush. With a little practice you will get the feel of the stroke and learn just the right amount of pressure to use. And, presto, you have interesting and exciting looking linear leaves or stems. Try it. Remember, in a realistic rendering leaves will seldom be seen in rigid, straight-on views. Usually they will turn towards or away from you. By turning the direction of your stroke pressure this feeling can be readily accomplished.

You'll find a partial listing of some of the more common leaf shapes on pages 121-123.

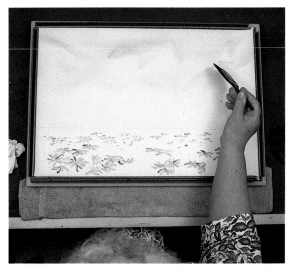

1 *After marking out with pencil the rough divisions of earth and sky, I indicated the basic shapes of the daisies I wanted to be prominent in the foreground. Then, with maskoid I covered the daisy shapes so they would be masked out when I started to run in the wet washes.*

2 *When the maskoid was completely dry – I usually let it dry overnight – the paper was wet with a sponge and wide brush. While the paper was still wet, yellow ochre was washed on the sky area in an oblique direction using a wide brush. Immediately over this still wet area a wash of Payne's gray was added. The pigment was heaviest at the top and allowed to lighten and fade as the color came down into the picture towards the horizon. Again oblique strokes were used. I was careful not to cover the entire area with the gray as I wanted some of the ochre to show through to suggest sunlight. All this time, of course, my board was tilted at a rather steep angle so the washes would flow downward.*

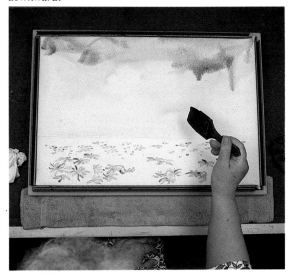

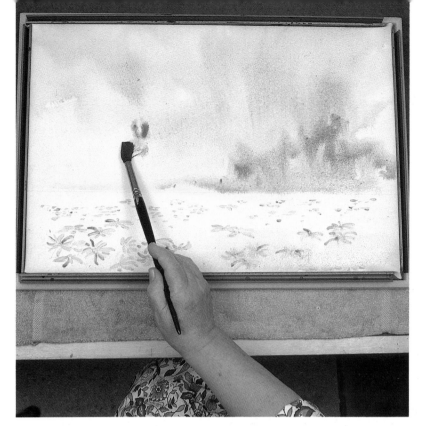

3 With the surface still wet and tilted, some cerulean blue
with a touch of raw sienna was added to suggest a distant
clump of trees. I tried to build the background trees into an
irregular and interesting shape.

4 Now for the foreground. First it was wet with a large,
clean brush and water. This allowed some of the still wet
sky color to blend into the grass area. The field grass was
painted in with a gradation of greens including sap green,
raw sienna and raw umber. The darker areas were held
towards the bottom of the picture, allowing the lighter areas
to recede towards the horizon. This will let the flowers stand
out in the foreground and will create a feeling of depth.

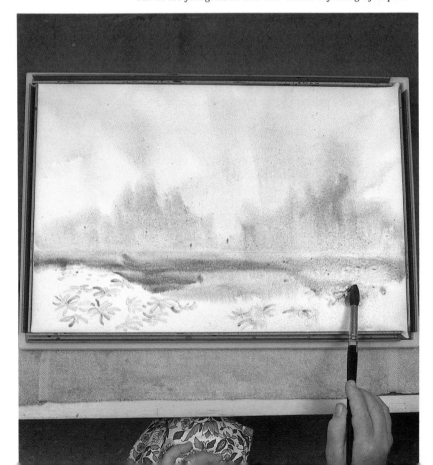

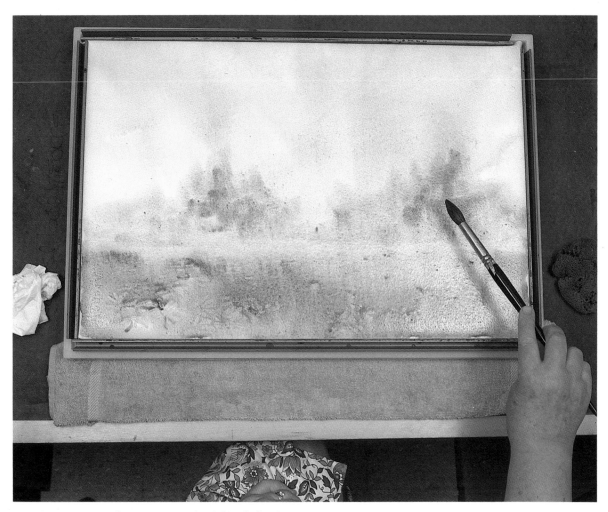

5 *Adjustments in color are now made. A bit of alizarin crimson is added to darken the foreground around the closest daisies. Also some splatter was added in the foreground for texture. I used a toothbrush for the splatter. I also built up the color and value slightly in the trees.*

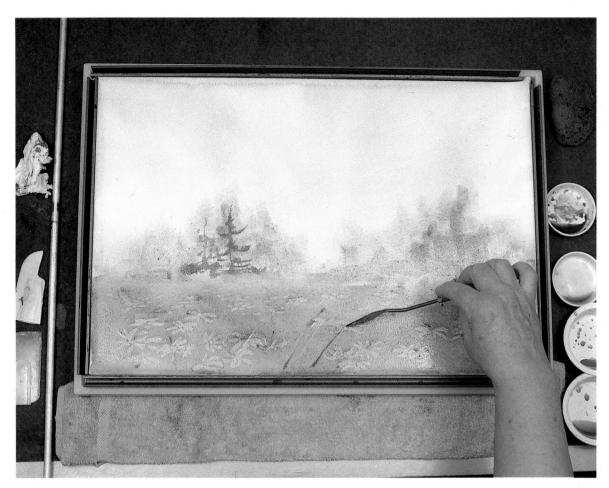

6　*Suggestions of waving grass were put in with a palette knife and a rather dry thirsty brush. With the picture quite dry I added a few more blades of grass, using a mixture of earth colors, sap green and a touch of Payne's gray.*

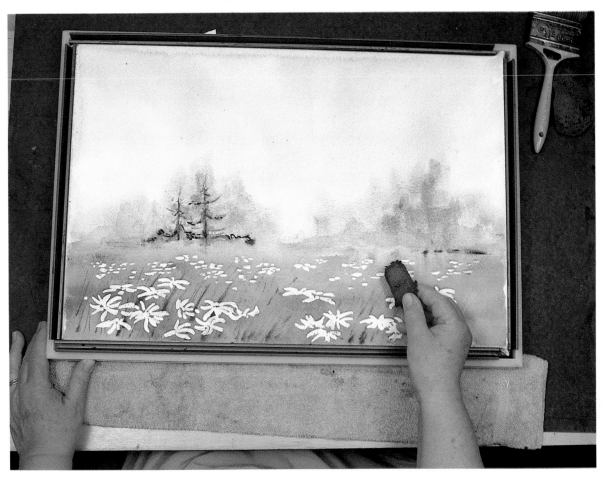

7 *The picture was now set aside for awhile to dry. When it
was thoroughly dry the maskoid was removed with a
pick-up.*

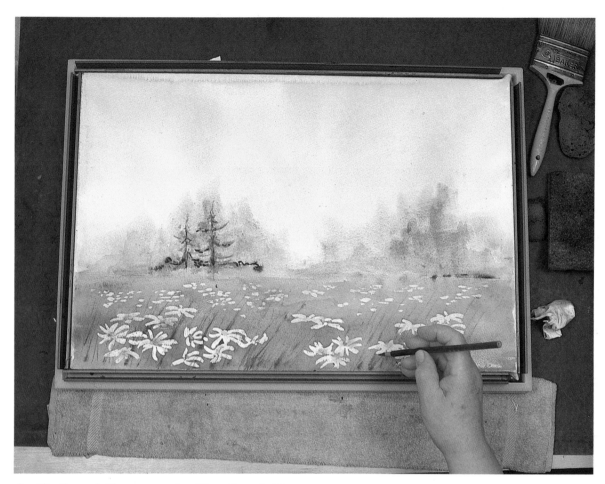

8 After the maskoid was removed and the pattern of white daisies was clearly evident, I decided the pattern of flowers in the distance needed some adjustment. Using an old bristle brush and clean water I loosened some color in the field and added a few blurred-looking daisies to make a better looking pattern. By blotting the area with tissue the daisies appear off-white and in the distance. The edges are soft. Some blue-grays of the sky were glazed over the distant flowers and some edges of those in the foreground. Touches of cadmium yellow, cadmium orange and a little burnt sienna were added to the daisy centers.

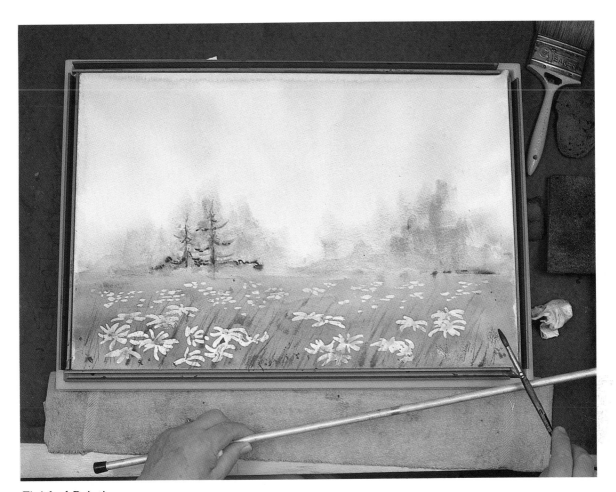

Finished Painting

Study of Two Roses

Subject. Two Roses

Materials. 300 lb. cold press 11 x 15 inches Palette: Lemon yellow, cadmium yellow, cadmium red light, burnt sienna, alizarin crimson, cobalt blue, cerulean blue, Hooker's dark green, thalo blue, Payne's gray. Brushes: Goliath round brush, #8 round sable, ½ inch flat sable.

Procedure. Light pencil lines indicated placement of the roses and bud. Begin with wet sponged paper. The spiral cone shape in center of rose was stated. The lightest tints of yellow for the first rose were painted and overlapped the petals from the cone center out to the edges. Blot the edges with tissues so some of them will be soft and lost.

Add darker accents with more pigment, also suggest dark shadows by using a flat brush to make chisel edges. Here I used a little burnt sienna added to yellow. Lift off some lights with a thirsty brush.

Paint red rose in same manner using cadmium red light, alizarin crimson and a very small touch of green added to alizarin crimson for the darkest shadows.

Add leaves with mixtures of greens using round brush and two strokes tapering the leaves at each end. Use flat brush in same way, painting half a leaf from end to end with each stroke. Lift light sides to some leaves. Add shadows to others. When dry, float in the background colors with gradations of yellow-green to darker cooler blue-green. Spray with mist to soften. Dry and lift other leaf shapes through stencil.

This single rose was done on a quarter sheet of 300 lb. cold press Fabriano paper.

After indicating a light pencil sketch for placement I put in a spotty covering of light alizarin crimson, mainly behind the area of the flower. This is allowed to dry.

A light wash of cadmium red is washed in over the flower area and allowed to dry.

With a mixture of cadmium yellow, thalo blue and sap green the leaves and stems are stated. A light wash of alizarin crimson is applied to the bud and the shadow areas of the rose. Just a touch of the green mixture is added to the bloom for accent. Let dry.

Now for the background. Using a Goliath brush with clean water, wet the background. A mixture of lemon yellow and cerulean blue is applied. While still wet some of the area is covered with a mixture of lemon yellow and cobalt blue. In spots a little Hooker's green and Payne's gray were added. A few drops of alizarin crimson are floated in to give some warmth.

When dry a mist of water was sprayed on some areas and leaf shapes were scraped out. Also some leaf shapes were lifted out using blotting and stencil method.

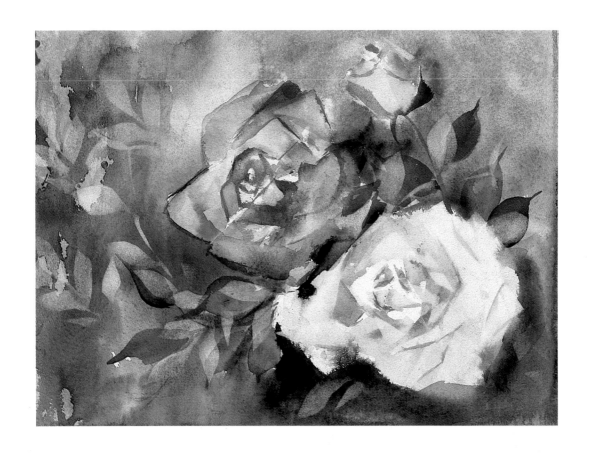

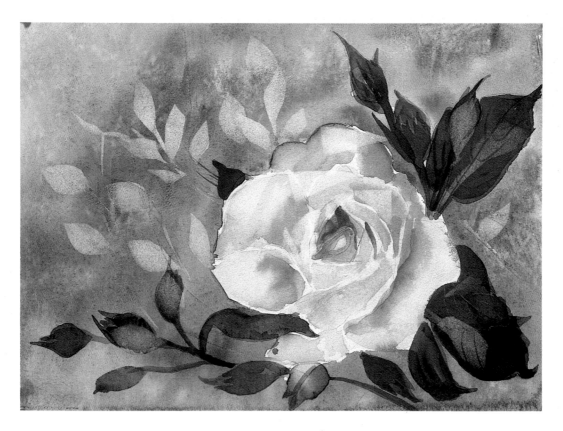

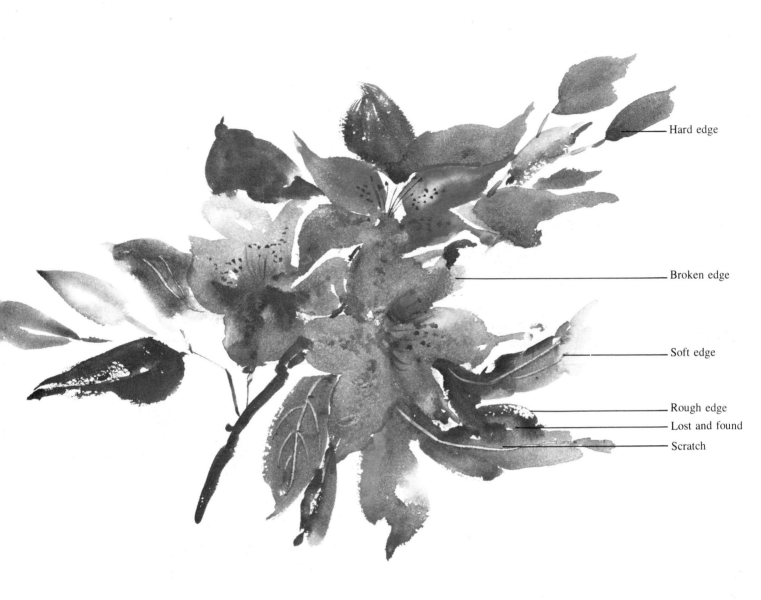

Hard edge

Broken edge

Soft edge

Rough edge
Lost and found
Scratch

EDGES

A good variety of edges is essential in painting flowers. In flowers, most edges appear to be soft, so you should try to complement these edges with hard areas wherever possible. Study the examples shown here to see the kind of edge variety you can achieve. Try to balance hard against soft; straight against curved: overlapped against isolated; lost against found, etc. It is the combination of all these considerations that makes for an interesting rendering.

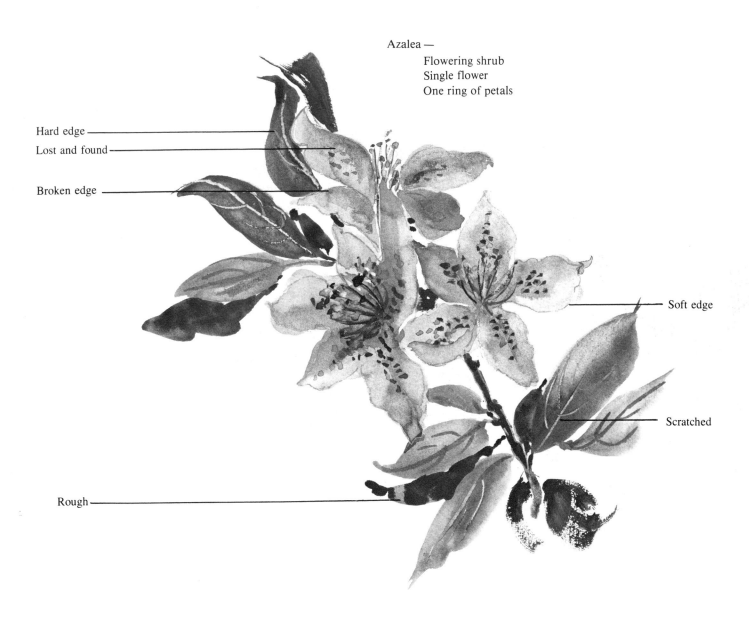

Azalea —
Flowering shrub
Single flower
One ring of petals

Hard edge

Lost and found

Broken edge

Soft edge

Scratched

Rough

CHAPTER 7

SPECIAL EFFECTS

REALISTIC

Of the many ways to paint flowers, it is likely the most popular approach is best referred to as realistic. In most cases this approach is something less than real. Usually it is a personal interpretation based sufficiently on fact to assure audience recognition. That is what I mean by a realistic or traditional painting of any subject. A look at some of the great flower paintings of the world will show they are often not that real or truly faithful to all botanical fact. The artist often only suggests what he sees. This suggestion, with a minimum of accurate detail, will usually be all that is necessary. This allows you to express your feeling about what you see without the burden of showing photographic detail. I think this is why a painting is so often more meaningful than a photograph of the same subject.

STYLISTIC

Flowers are sympathetic to stylized treatment. It is fun to do. The forms and shapes can be readily organized into pleasing arbitrary designs. Usually it requires a good deal of simplification. Good variety and balance are required, but the shapes lend themselves to this easily. Stylizing is a good exercise in design. You can use your imagination in line, shape, and color and not be restricted by reality.

SYMMETRICAL

Oriental rugs and many wallpaper designs show how effective flower designs can be when treated in a conventional manner. Use your design sense and let yourself go. A feeling of balance, rhythm and harmony are needed; qualities most of us have, but too often fail to explore. Try doing some renderings. Many people find it enjoyable, and it is a fine way to learn to control the medium, select color and simplify shapes.

ABSTRACT

In any abstraction, the emphasis is on the arrangement of the forms, colors, values, and lines to produce the desired effect. Although the forms are usually based on real objects, the final result may not resemble them at all. I find, however, in an abstraction of flowers the subject is usually recognizable. Of course, particular types of flowers and details are not likely to be apparent, as the purpose is to eliminate such physical elements as non-essential to the purpose of the picture. It is good practice to try some abstracts, as it forces you to think only about the picture structure.

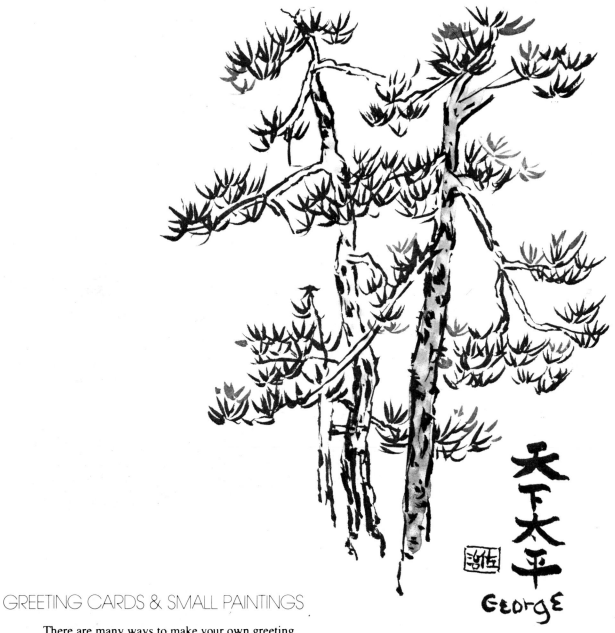

GREETING CARDS & SMALL PAINTINGS

There are many ways to make your own greeting cards or small paintings, using floral subjects. It is a delightful experience for any painter to give an original, and a pleasure for the one who receives it.

An eighth of a sheet of Arches, or any other good watercolor paper, so folded that it measures 7½ x 5½ inches is a good size for a card. Open the paper, flatten it on a board, and put masking tape around the edges of your proposed picture area. Cut or tear a few shapes of masking tape for the white flower shapes and place them in a focal spot. Float the background with colors, thinking of gradation and contrast. When the shine has gone, scrape in a few leaf shapes and add a painted leaf shape if you wish. When the paint is dry, lift the masking tape, add flower centers and shadows to the flowers. Sign your initials and you have a colorful greeting card with a neat border of white paper.

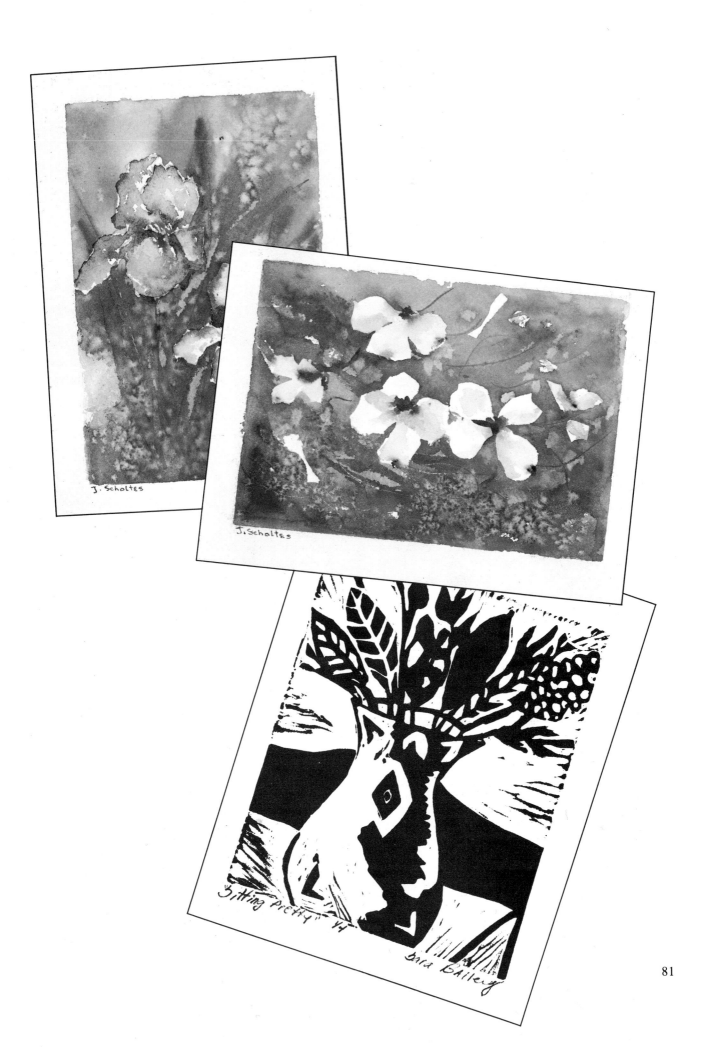

81

CHAPTER 8

FLOWER PAINTING

LILACS

Think of lines, shapes, color and textures of lilacs. Think of how lilacs grow, how they are cut and how they are arranged. How best would the composition you want to paint be arranged? Would the main theme be obliques and the secondary theme be curves? Would you want a vertical or a horizontal painting? Think of the structure of the lilac.

Lilacs grow as flowering shrubs. Some can be tall bushes and others planted as informal hedges. When I was a child, our long driveway was bordered on the side away from the house with a screen of beautiful lilacs. On the other side were the vegetable gardens and some small fruit trees which blossomed in the spring. Beneath the border of lilacs were masses of yellow and white daffodils. Partly because of this I love the beautiful, fragrant lilacs.

Lilacs have improved with breeding from the common purple and white species to many-petaled blossoms, large clusters, and a wide range of color —they can be white, pink, yellow, or many shades of purple and blue. Our lilacs grew quite tall and had to be pruned late in the winter. Suckers produced below the point of union were removed, weak growth was removed, and care was taken not to cut stems of flower-bearing buds.

Some species of lilacs have single blossoms with one row of petals, others have double rows of blossoms, with numerous overlapping petals. Foliage on the lilac shrubs is dense, the leaves are heart shaped with veins turning downward toward the tip.

In terms of shape the theme for a lilac painting would be more curvilinear and oblique than square, horizontal or vertical. The color dominance for blue to violet lilacs would be cool. With some white lilacs added, the values could be from the lightest flower to the mid-tone background, and some mid-tone flowers to the darkest leaves.

The plan would be to know the shape, structure and colors of the flowers, buds, stem, leaves, and branches; then to study the techniques of painting each. The flowers in clusters would have an all-over cluster shape with irregular edges. This could be a somewhat large cone shape with irregularities. The single, double, and overlapping blossoms need not be painted one by one. The whole cluster shape could be painted with water or the lightest tint and drops of blue, alizarin crimson, and violet. Even green could be added wet-into-wet to give the illusion of many little flowers. When dry, several little flowers could be defined in more detail.

To begin, make a value sketch in proportion to the size and shape of paper selected for your painting. Decide how you want to begin the painting — dry or wet. Decide which colors and brushes you plan to use. When all materials are ready, the value sketch made and the real lilacs before you, take a deep breath and enjoy the fragrance of the blossoms. Think soft, fresh, fragrant color, then pick up your brush and paint.

Perhaps the point of greatest interest is the best place to start. Here you will want the most eye-catching color, the greatest contrast, and directions of other objects in the painting leading to this point. A secondary interest must not be as important as the focal point.

If there are white flowers, they will reflect color and be tinted with a little cool yellow or pink (a light wash of alizarin crimson).

Be careful not to apply the white paint too thickly. Change the whites in the middle with a little

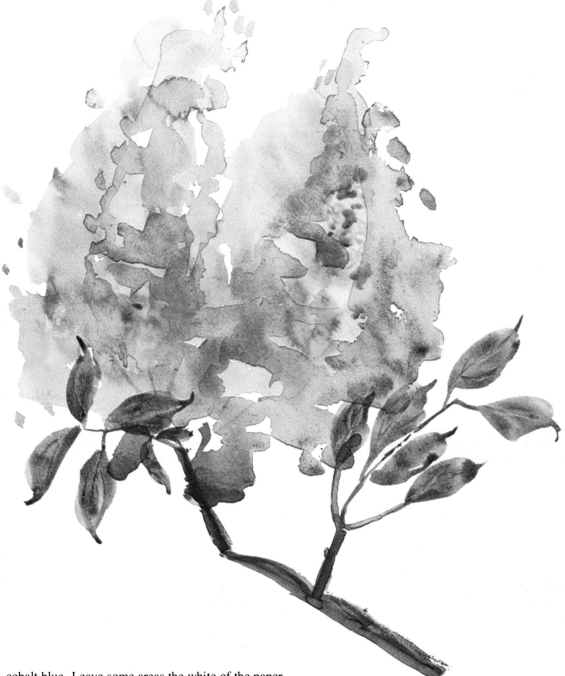

cobalt blue. Leave some areas the white of the paper. Blot some areas with tissue to soften and lose them.

For the blues, try Prussian, cobalt or ultramarine blue. If painting wet-in-wet, test for diffusion then go over the whole flower with a tint. Drop suggestions of little flowers in spots. Go around the flowers with a mixture of Prussian blue and a little viridian (less water). Think of curves in the shapes. Think of curves while putting in the background. Let some of the background blend in. Keep working the background so there will be no hard edges. Keep both sides going. At times a misting of water will give a soft, distant, textural effect. A little alizarin crimson can be added for points of interest and variety in the background.

One end of the painting can be made darker by adding Payne's gray or ultramarine blue. Add more curve shapes before the paper is dry. Spatter a little

lemon yellow. Blot some white edges if it bleeds in too much. Take a thirsty brush and pick up some curve shapes on a few of the edges to soften them.

At this point, before the paper is dry, but after the wet glisten has gone, a little coarse salt can be sprinkled over the flowers to create suggestions of some small, lighter flowers in the clusters. The blue lilacs can be a big pattern of cobalt slightly darker than the background. Watch the shape. Do not have a worm shape, but an irregular cone cluster or two interlocking ones not the same width. Add a little lemon yellow to the cobalt. Go around the big piece or large flower shapes with some darker leaves.

The leaves could be a mixture of thalo green and alizarin crimson or thalo green and burnt umber. Try the color where you want it.

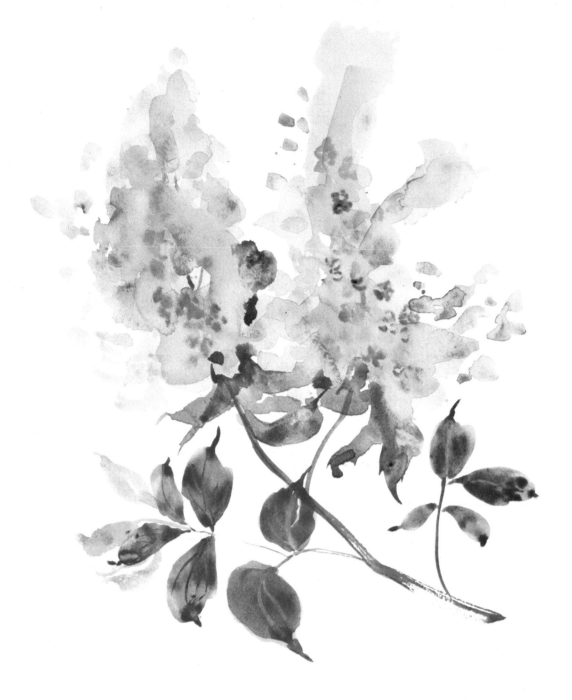

The lilac leaf, oval or somewhat heart shaped, comes to a point. Try making this leaf with two brush strokes, bringing the brush to meet in the center line and to a point at the end. Soften some edges with a thirsty brush. Find and lose some edges. The flowers must be fresh and soft. Color changes can be made in the leaf color with touches of yellows and alizarin crimson. Some blotting can be done with tissues. Connect the darks. A little raw umber, Indian red and yellow ochre can be used for variations in the stems. Some stems can be scraped in. Think of curves. A rigger can be used towards the last for some of the fine stems. The lighter side of a stem can be lifted with a thirsty brush or carefully pressed with a scraper. Do not use the scraper as though you are cutting, but gently press as though buttering or icing.

Not all flowers should be of the same importance, the less important ones away from the focal point and the secondary point can be given a glaze to make them less obtrusive and to lose them into the background.

While the flowers are still damp, a little green can be worked into the cluster to define the structure. Lemon yellow and viridian make little stems in the flower. Vary the value. A little Payne's gray can be glazed over the darker side of the lilac and underneath. A little cobalt and ultramarine can describe a florette and make a dark center in light blue areas. Some lights can be picked up in the blue lilacs with tissues. Vary lines. Vary sizes. Regain some of the flower cluster shapes with a dry slight touch of Payne's gray blended off into the background.

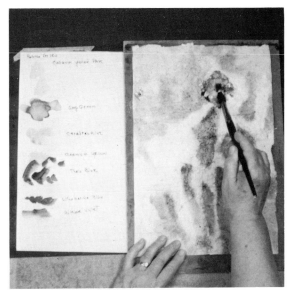

IRIS

There are more than 200 species of iris that grow wild, and thousands of hybrids. All have sword-like leaves and a distinctive flower structure. The flower consists of three usually erect petals called standards, and three outer petals called sepals or falls. The falls hang down from the base of the blossom. Between each pair of standards and falls rise the flower's reproductive organs, often crowned with colorful crests.

The name iris comes from the Greek goddess of the rainbow because of the species' many beautiful colors. These range from snowy white through red, pink, orange, yellow, blue, lavender, purple, brown and near-black. The flowers are from 3 inches across to 8 inches across. In this demonstration I have used the purple bearded iris.

For the iris in this demonstration I used Masa, a Japanese printing paper which is smooth on one side and slightly rough on the other, like rice paper. The smooth side is less absorbent; however, I sometimes get confused if I have not marked it, because I cannot tell the difference when it is wet.

In past years I made many experiments trying to get the batik background Robert Laessig uses in his painting of flowers. None of them worked. Some papers disintegrated when wet and crumpled. Some were too stiff and too heavy. This paper works if you handle it gently.

In addition to the paper for painting, I have another sheet of Masa paper at least two inches wider all around for the mounting process, and paste to mount it. A paper or cardboard roller is also used in this process.

My palette consisted of Winsor violet and a violet I mixed with ultramarine blue and alizarin crimson, Winsor or thalo blue, cadmium yellow pale, cadmium yellow, raw sienna, burnt sienna, cadmium red and sap green. Some of the greens were mixtures of cadmium yellow and thalo blue with a touch of warm color. Some of the middle greens were cerulean blue, raw sienna, sap green and a slight touch of cadmium red.

For most of this painting, I used a #14, series 7, Winsor & Newton brush, which is a round sable with an excellent point. This brush carries sufficient paint for large areas and holds a very fine point for small details.

I used a 2-inch flat nylon brush to apply the paste to the back of the finished painting, a bottle of clean water with a spray attachment for a fine mist, and an old brush for splatter.

First I creased the Masa paper in sharp even folds to be cut to size. I cut a quarter-size for this small painting and used it vertically to relate to the shape of the tall iris.

I sketched a design of iris to help me in the demonstration. I usually do not sketch for paintings on Masa paper and I never sketch on rice paper, rice boards or silk.

The next step was to crinkle the paper. I placed it on tempered masonite and then used a wide soft brush to wet it until it was limp and saturated. During this process it was turned from front to back and brushed with water on both sides, then allowed to dry until it no longer looked shiny. At times I would lift the paper to let air circulate under it. This process should not be rushed if you want fine, interesting webs or crinkles.

To crinkle the paper, gather it from top to bottom and from side to side, bringing it into a sphere form. Give it a squeeze, but do not make a hard ball of it.

The larger piece of Masa paper was rolled onto the cardboard roller with the rough side out. This was ready to use for backing the paper.

Clear non-staining Metylan wallpaper paste was mixed with enough water to make a thin jelly. I have mounted rice paper with a cooked flour-and-water paste and backed it with mulberry paper, but Metylan seems to work best. The paste keeps indefinitely in a covered plastic bowl.

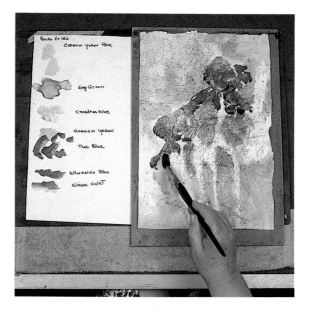

Gently open the sphere and flatten the paper as much as possible on the masonite.

My next step was to paint. Sometimes I let the paper dry first, and occasionally begin while the paper is still damp. Here, I started with background colors while the paper was still damp, using the yellows, earth colors, and greens. I suggested some diffused leaf shapes and tried to leave some thin whites. The flower shapes were painted with brush strokes following the structure of the iris, beginnning at the center, using the brush with lifting, pulling, turning and rolling strokes in a variety of pressures, with different values of violets to purples, a blue here, and a little touch of alizarin crimson. The stems, which have a distinctive pattern of crossing V-shapes, were added while some of the flower petals were still damp so the colors would blend.

At this point the drawing was lost. I had a vase of iris before me and I also had my memory and imagination. With bright lights and a camera over my head, the background colors got too heavy. I sprayed with a mist of clean water and lifted some of the color with a sponge and tissue. I suggested a few more sword-like leaves and added the colorful crests.

After the painting had dried, it was placed face down on a piece of masonite large enough to allow for a border of backing paper at least two inches larger than the painting. A mist of clean water was sprayed on the back, and the painting was gently smoothed flat.

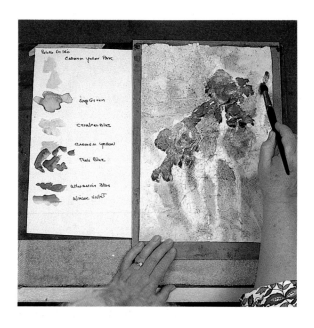

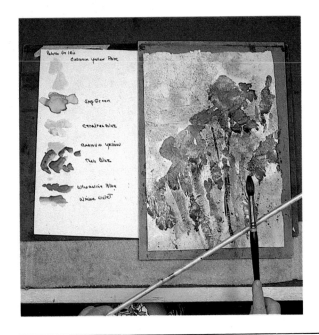

The paste was brushed on gently from inside toward the edges with a 2-inch nylon brush, then smoothed by hand. The roll of backing was placed to overlap all four edges of the painting, then rolled down and smoothed to adhere to the painting.

The painting was then lifted, the board wiped clean with a plastic sponge, and the mounted painting placed on the board, face up. The edges were carefully pasted to the board so no paste could get under the painting. Finally, the painting, backing and pasted edges were allowed to dry. Some stretching also takes place at this point.

The stretched, dried painting then had a few touches of clorox added where I wanted a white or lighter tint. The greens still seemed too heavy, and so I held the whole painting under the sink spray and aimed the spray on the heavy green areas. The painting was allowed to dry and then cut at the edges with a razor blade. The pasted edges were washed off with water, and scraped away with a little palette knife.

Iris II employed the same technique except that flowers were painted first and background last.

From nature, a careful drawing was made using the vertical format. Buds and leaves form a series of V's around the main stalks.

After color studies were made, these were used: Winsor violet, cobalt blue, alizarin crimson, ultramarine blue, yellow ochre, cadmium and lemon yellow, burnt sienna and Winsor green.

Colors used for the flowers were lemon and cadmium yellow for the colorful crests. Winsor violet, alizarin crimson and ultramarine blue were used for the standards and the falls and for the prominently veined petals. A light wash of Winsor green with yellow ochre, a wash of green with cadmium yellow, a wash of green with burnt sienna and cobalt blue, and a wash of alizarin crimson were used for the stems and leaves.

The flowers were started with the yellow crests. The yellow was allowed to dry. The petals were painted with clear water. Drops of Winsor violet were floated on the wet petals taking forms of varied values and rhythms. This was all kept light and transparent. A little thicker Winsor violet with a tiny touch of green was picked up by the point of a medium-sized round brush and, in the fewest strokes, described the character of the buds. This was allowed to dry. The same procedure was repeated, dropping Winsor violet on the flowers after they were painted with clear water. To this a touch of ultramarine blue and alizarin crimson were added where I saw slight changes in the hues. A tint of the flower color was pulled from the petals down into the calyx. The palest washes of

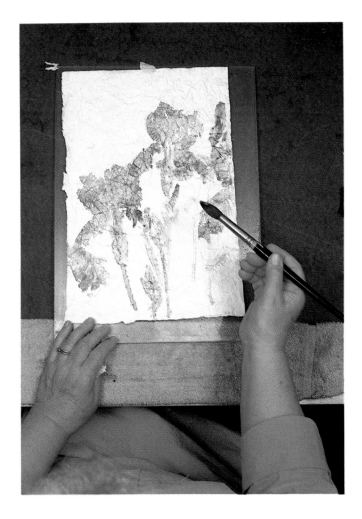

green were added to the stems and repeated washes were added to vary the value and the hue of green. With a loaded brush, the sword-like leaves were painted with one bold sweeping stroke. This was allowed to dry. A wash of alizarin crimson was added over the stems, the casing holding the buds, and the leaves.

After all large shapes were painted and dry, a shadow of cobalt and burnt sienna (a very pale gray) was added under the yellow crests. A little splatter was added for texture and a few detail lines were put in to help describe the flower structure.

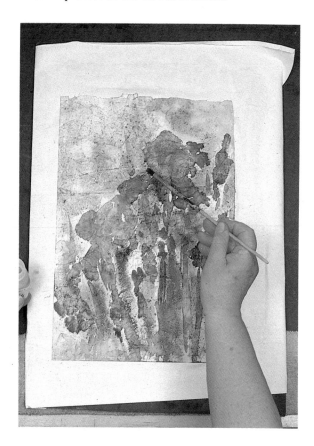

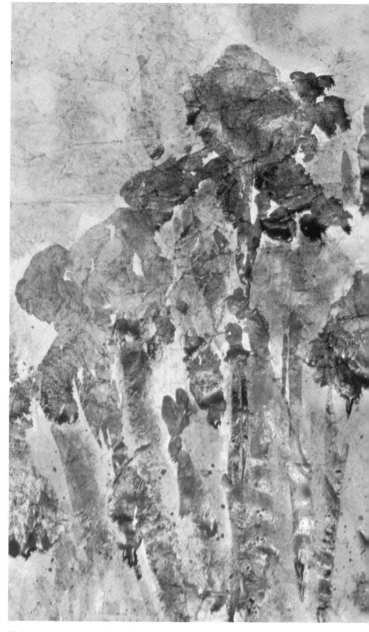

Enlarged detail of finished painting

LILIES

Decide where you want the most important point of interest. Plan to have the most important flower, and the greatest contrasts in value and hue also at this point. Place this point where it will be at a different measure from all four sides. Then, holding your pencil or brush at arm's length, take a measurement of the height of the largest bloom and place these marks on your paper. Now with the same steps take a measurement of the widest part of the bloom. Try to make flowers as large as they are in nature or slightly larger.

When you have the largest blossom placed and are sure your paper is large enough to keep the remaining part of the plant in proportion, try lightly sketching a good shape for the lily. It is basically a tube shape. You may see it from a front view, side view or turned in a different way.

Study the structure of the petals. Lilies have a definite number of petals and some turn back and curl under. Some have upright flowers, some have outward-facing flowers and other species have pendant flowers. Some have trumpet shaped blossoms, others have bowl, sunburst and star shapes. Some of the backswept petals may not show.

Whatever the flower, try to make the shape an interesting one—which means not all the same in dimensions each way, but two-dimensional, with some interlocking shapes of another blossom or some buds. Lilies have fascinating and numerous buds.

Think of the whole pattern—the flowers, buds, leaves and stems as the positive shape. Think of the unpainted parts as the negative shapes . The negative shapes should have variety and interest and be in proportion to the positive shapes and lines.

Usually I make a little pencil mark at each side, top, and bottom of the edges to aid in avoiding a static placement in either the vertical or horizontal center.

Stems grow somewhat at an angle naturally. When in a container they come from one opening. Some artists say stems should not cross, and others cross them. Try to have a pleasing design whichever way you direct the stems.

When you feel you have planned your design well, prepare your paints and have all brushes, tissue, water, sponges, and other materials ready. Be sure the colors you plan to use are workable. I like to have some saucers of washes ready as well as a well-prepared palette, and I like at least two good-sized containers of water. Always keep clean water for painting. Wash your brush in another jar or change the water frequently.

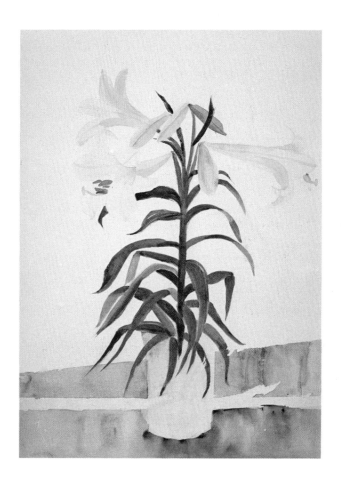

If you are painting on paper less heavy than 300 lb. and larger than 11 x 15 inches, you will have to have the paper stretched and fastened to a board while it is expanded, or use so little water that it will not buckle. Or you can paint the wet technique.

Paint from a plan: back to front, large to small, light to dark. Consider the focal point. Relate the pattern of darks and lights.

Think dominance of color. Lilies are usually a hot color while the foliage is a cool color. The background could be made warm so that the dominance of the whole painting would be warm.

Color in the flowers differs with the species of lilies. The Asiatic and tiger lilies are usually orange to cadmium scarlet with highlights and shadows of browns. Orange and burnt sienna can be varied for some. Cadmium red light can be added where a warmer touch is needed and lemon yellow can accent

a cooler part of the flower. A little green can be added for a color change and a little Indian red can be added for a dark.

If you are painting the wet technique, you must test your color in the center of the area to be sure the paper is not too wet and that the paint will not spread. This also means there should not be too much water in the brush.

When the flowers are painted, the background of warm dominance can be painted. Some of the flower color can be dragged into the background, but avoid drybrush in flowers that are soft. Make the background all one color, such as a wash of yellow ochre. Then flood some other colors into it for gradation such as Indian red and a touch of thalo green to gray it. Think of obliques and not straight vertical or horizontal brush work. Think of repeats of color.

While rough brushing is not good for soft flowers, there should be variety in the edges—some soft and some lost, some more definite or hard. The centers of lilies contain the inner surface, the T-shaped stamen and central style (all about equally long), the stigma spreading its three parts after the anthers have split open and displayed their golden pollen. This part of the flower can be lifted with a thirsty brush, sponged out through a stencil or carefully pressed out with a buttering motion of a knife. The dark tips can be added when the paper is perfectly dry. The darks and leaves can be cut around the flower shapes with a rich mixture of yellow ochre and thalo green with a touch of Indian red.

Variations in the greens can be made by different amounts of green, yellow and red, mixed on the paper as well as on the palette. The stems tend more toward a lemon yellow, as do the buds. A touch of orange or cadmium red light can give form to the bud. Some stems vary toward burnt umber. Some stems and leaves can be scraped in when the paper is the right dampness. A rigger can add a few thinner stems.

The tiger lily painting was done on wet paper to keep the background and the flowers soft and fresh. The negative areas were put in with a 2-inch brush using burnt umber, a little Payne's gray, yellow ochre, a touch of thalo green and Indian red. The mid-tones were in gradation of warm to cooler washes with some water spotting for variations. A two-dimensional light shape was kept to suggest light behind the flowers. Some color was dragged into this shape and into the flowers. Some colors were floated into the background color. Orange and burnt sienna were used for the flowers. The color was tested for diffusion to check its spreading before the flower shapes were painted. As the flower shapes were painted, some edges were lifted with a thirsty brush and blotted with tissue. As the paper became drier, the water had to be used carefully. Too much water with the pigment at this point can cause run-backs.

Check at this point to avoid a too geometric or

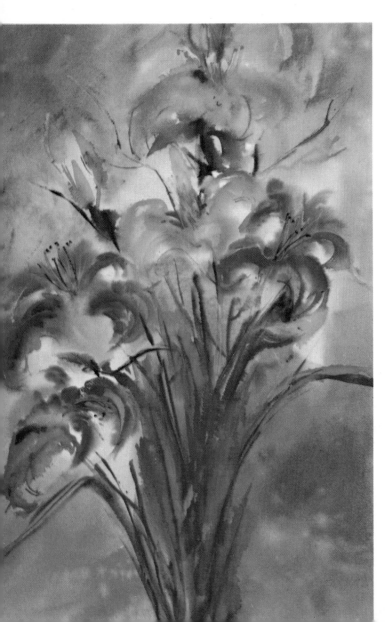

static shape. A little glazing of cadmium red light was added to some flowers for warmer color and a little lemon yellow for cooler color. Some Indian red and burnt sienna touches made dark lilies. A little green and a touch of cadmium red added more gradation or change.

When the paper was dry enough to have the color squeezed out without running back into the line, the stamens were lifted, and the little dark tops added. The first theme in this painting was obliques, the second theme was curves.

The leaves were a mixture of thalo green and yellow ochre with a touch of Indian red. The buds were yellow-green. Some stems were scraped, some were painted with burnt umber, and others were scraped to create light green against dark green.

The large painting, 22 x 30 inches, on Fabriano 300 lb. cold press was done from a living Asiatic hybrid lily plant and was painted in my studio. (See title page.)

The vertical 22 x 15 inch painting described step-by-step as a ''warm painting'' was painted from lilies in our backyard. These are called day lilies (Hemerocallis fulva). They do not grow from a true bulb, but from a rhizome resembling a thickened stem which grows horizontally, weaving along the surface of the earth. We have both the tawny-orange and the yellow varieties. Both are funnel shaped with flowers 3 to 4 inches wide. While they open just for a day, buds continue to open. They usually have three petals and three sepals, all the same color. Their leaves are narrow and 2 to 6 feet long but do not stand as high as the tall-stemmed lilies.

MARGUERITES

Golden Marguerites or Anthemis are listed in my garden books as perennials; however, mine do not last more than one year. I plant new Marguerites in front of the taller shasta daisies which bloom later, and I cherish them in the garden. They grow well and have yellow daisy-like flowers about 2 inches across. The foliage is dense and fern-like. They are good for cutting and lovely to paint, combining well with other flowers for bouquets.

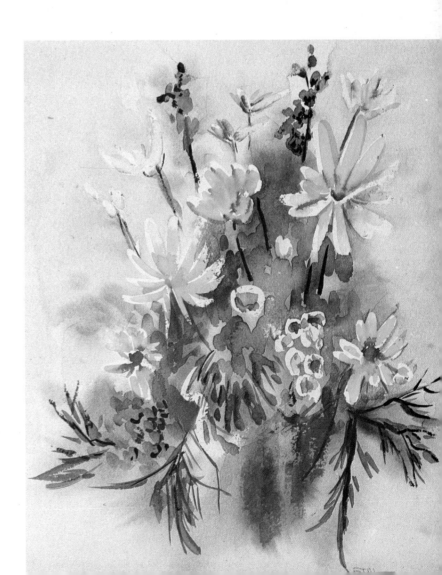

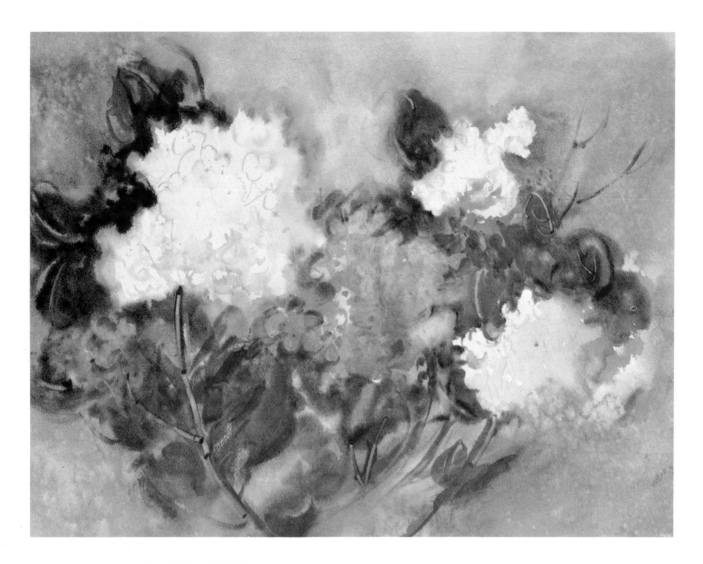

HYDRANGEA

The common bigleaf hydrangea grows as a single shrub, or can be massed in borders. The shrubs grow three to five feet in height and width. They produce large globular flower clusters up to ten inches across. There are white, pink and blue flowers.

This painting of hydrangea was done on Arches 140 lb. cold press paper. The paper was saturated with water on both sides, and placed on tempered masonite with a bath towel underneath. The plan was to have a predominantly cool painting, with the theme curvilinear. In planning the dominant colors were cool, the shapes, curves, and the textures soft. Gray was to be the background color; flowers were to be white and blue; leaves or foliage dark greens.

The design was started with the large light shape and a decision on the direction of the light. This large light shape was two-dimensional with interlocking edges and variations of hard to soft, found to lost, wet to dry. The darks and lights were placed in mid-tones. I tried to have more light than dark. There were three different-size lights. The white areas reflected color. A little lemon yellow (cool yellow) and a delicate suggestion of pink (alizarin crimson) was added. A wash of cobalt blue was added in the middle, but most of the white flowers were left white. Tissue was used to blot and soften edges. The background was to have been neutral; however, it was more blue than gray.

I had Prussian blue, cobalt and ultramarine blue on my palette. Diluting this with a little water, I added a touch of viridian and started in one corner, then came in around the white flowers and right over the blue flowers. I tried to make curves in the background and let some of the background color blend in with the flowers to avoid hard edges. I kept working both edges to avoid hardness.

Tissue and a thirsty brush were used to soften some edges. A little salt was sprinkled on the background and flowers to give variations in color and texture.

The dark leaves were added with thalo green,

alizarin crimson in some areas and a mixture of thalo blue and burnt umber in others. Some edges were softened with a thirsty brush lifting the color. A few of the leaves had a little dry brush, but not the flowers. Flowers should be soft and not painted with dry brush.

For variations in the darks, a little raw umber and Indian red were added. Some of the stems were burnt umber, raw umber and a touch of Indian red. A rigger brush was used, one or two were scraped with a small knife. A little pale green was worked into the white flowers to give some definition. Little florettes were described with a tint of cobalt, ultramarine blue and a wash of lemon yellow. Dots suggested some centers. Sizes varied. Some lights were lifted in the blue flowers, and a few shadows and curves were added.

To keep the eye from going to the bottom middle-sized white hydrangea, a wash of ivory black with a touch of cobalt was quickly glazed over most of the flower. To make the important white flower stand out, a touch of Payne's gray was added for contrast in a few places in the background.

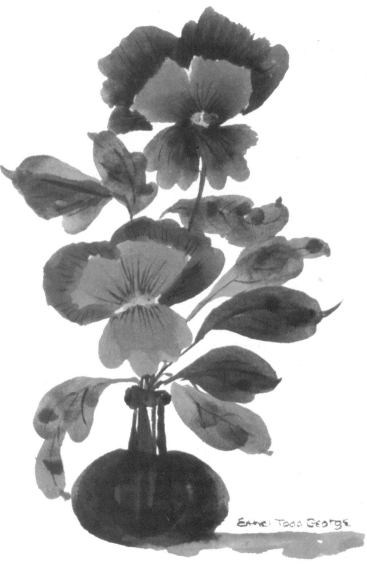

PANSY

The pansies in my paintings have come from a nursery in Greenwich, Connecticut, where there are fields of beautiful plants in all colors. They make colorful borders for flowers in the early spring and are lovely in hanging baskets. They grow well until weather becomes too hot.

The familiar pansy grows about 8 inches tall. The flowers are 2 to 3 inches across and come in many colors ranging from yellow, dark red, brown, various shades of blue, purple and white. The quaint markings make pansies look like faces. The sprightly-faced flowers make charming nosegays and small flower arrangements. Pansies belong to the family of violas and modern varieties go back to the days of heartsease and Shakespeare's pansies.

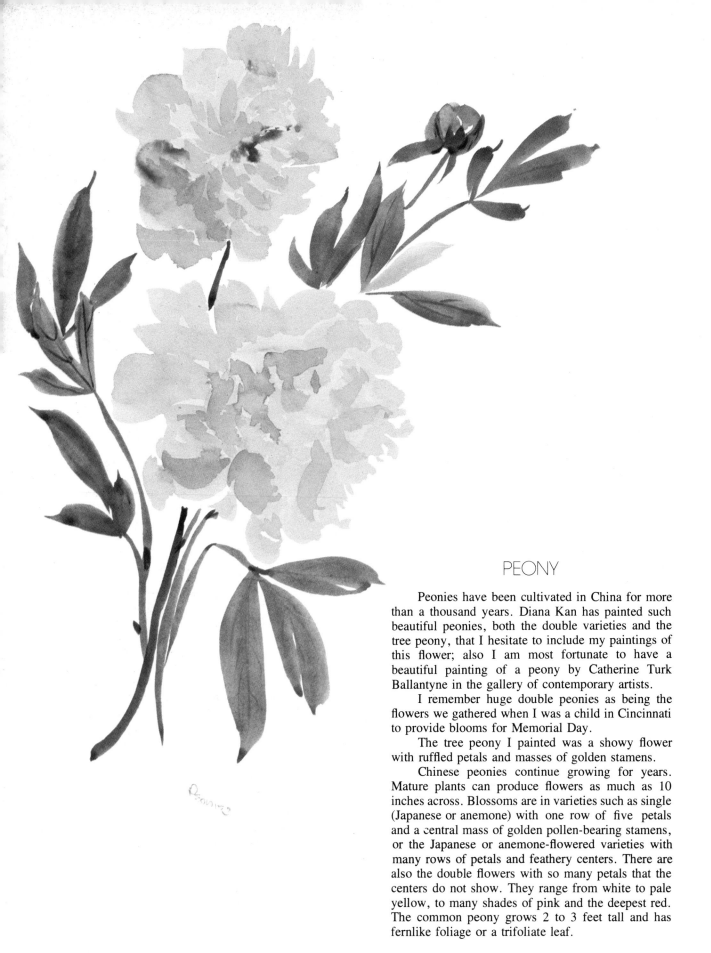

PEONY

Peonies have been cultivated in China for more than a thousand years. Diana Kan has painted such beautiful peonies, both the double varieties and the tree peony, that I hesitate to include my paintings of this flower; also I am most fortunate to have a beautiful painting of a peony by Catherine Turk Ballantyne in the gallery of contemporary artists.

I remember huge double peonies as being the flowers we gathered when I was a child in Cincinnati to provide blooms for Memorial Day.

The tree peony I painted was a showy flower with ruffled petals and masses of golden stamens.

Chinese peonies continue growing for years. Mature plants can produce flowers as much as 10 inches across. Blossoms are in varieties such as single (Japanese or anemone) with one row of five petals and a central mass of golden pollen-bearing stamens, or the Japanese or anemone-flowered varieties with many rows of petals and feathery centers. There are also the double flowers with so many petals that the centers do not show. They range from white to pale yellow, to many shades of pink and the deepest red. The common peony grows 2 to 3 feet tall and has fernlike foliage or a trifoliate leaf.

POET'S NARCISSUS

Poeticus, or poet's narcissus, grows in my garden, so I have become aware of the characteristics which make this a species or group of Narcissus genus. The plant heights average 12 to 16 inches, with slender foliage or basal leaves growing from bulbs. These leaves turn and twist in graceful rhythms, ending in tapered tips. The stems, averaging two to three-eights of an inch in diameter, bear one flower each. The flowers vary in size from 2 to 3 inches in diameter. The centers are small cups or flat crowns of yellow-orange tipped with very shallow ruffled edges of light red. Tiny yellow-tipped anthers holding pollen can be seen inside these cups. Outside, the six snow-white petals are held in a cup of green called the calyx.

The petals have fascinating shapes, and the way they twist and turn creates interesting variations and rhythms. The snowy-white petals become soft tints of pink, yellow, blue, green and violet as they pick up surrounding colors, creating new shapes and delicate shadows.

For my first study of the poet's narcissus, I used a felt tip pen on a 15 x 11 inch piece of Fabriano 140 lb. cold press watercolor paper, and made a line drawing study of one flower held in three different positions.

Next, I prepared my working area with the Fabriano paper on a masonite board. I did not need tape or clips for this small study. At my right side (because I'm right-handed) I had the materials needed for painting. My palette consisted of:

Yellow Ochre
Raw Sienna
Burnt Sienna
Raw Umber
Burnt Umber
Aurora Yellow
Cadmium Lemon
Cadmium Yellow
Cadmium Orange
Cadmium Red Light
Alizarin Crimson
Ultramarine Blue
Cobalt Blue
Winsor Blue
Cerulean Blue
Sap Green
Viridian Green
Hooker's Dark Green
Payne's Gray
Thalo Blue

I also had several small saucers in which I could mix the tints and delicate washes of yellow ochre, ultramarine blue and alizarin crimson. For my greens I mixed combinations of cadmium yellow plus viri-

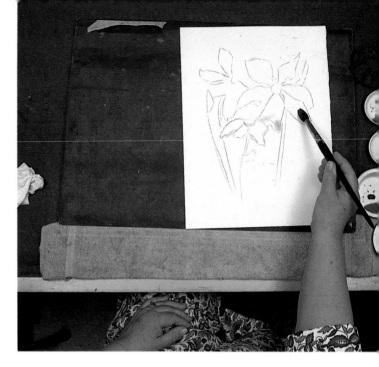

dian, cadmium yellow plus cerulean, aurora yellow plus viridian, cadmium yellow and sap green plus a touch of cadmium red light, cadmium yellow, thalo blue plus a touch of alizarin crimson, ultramarine blue, cadmium yellow and burnt umber, and raw umber plus Hooker's dark green.

I worked with only one brush; a Series No. 7, size No. 14 Round Winsor & Newton Sable.

Two containers of water were used; one for washing my brush, and the other for clear water for painting. Flowers are fresh and clean, and should not be painted with dirty water. To attain this freshness, there should be given as much thought as possible to avoid over-working and over-painting which results in muddy colors.

On my table were also a small natural sponge, a box of tissues, a plastic spatula, and blotters.

With a very light touch and a No. 2H pencil, I barely indicated the centers of two flowers. One center was a little lower than the other and turned in a different direction. From these centers I indicated the petals, observing the spaces in between as well as the shapes of the petals. The negative shapes of background between the petals vary, as do the petals. The calyx, capsule and stem were sketched. The curling sheath was lightly suggested, and I was ready to paint.

I covered the whole flower shape with the very lightest of lemon yellow, then quickly blotted the lightest white shapes with tissue. While this wash was still slightly damp, I added the small cup shapes with a touch more of lemon yellow, then a touch of cadmium yellow and a tiny ruffle of orange and cadmium red light. This I blotted with tissue. Then, with the tip of my brush I added a line of cobalt tinted with water to a shadow edge and quickly painted with clear water to leave a delicate gradation of shadow. I followed this with soft green and violet shadows. Stems and leaves were suggested with light washes.

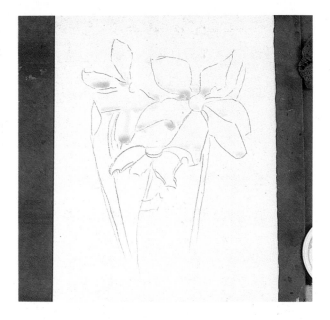

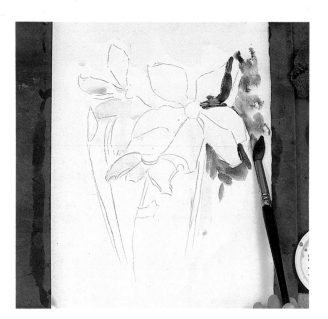

Wash the brush. Give it a shake and learn by practice just how much water and paint you need to pick up. You will need enough to move the paint as you wish, but not enough to lose control. You can also learn to use water and different colors in one stroke to create color and value changes with different strokes and pressures.

While painting the flowers, stems and foliage, I washed in some of the same tints all around them, letting some of the petals blend in with the background, creating a larger light area on the right side of the painting, and tying the right light shape to the top of the painting.

Not having been saturated with water, the paper did not buckle. Soon it was scarcely damp, and color could be controlled to bring out the petal shapes and still be carried into the background without hard edges. I loaded my No. 14 brush with rich mixtures of greens, blues and alizarin crimson and brought it to a point by turning it on my palette. Next, I looked for a straight, a curve, a tip, and a rhythm of a petal. With one stroke I tried to identify that gesture. I followed this by rolling the brush to carry the rich colors away from the light flower, and to vary them in a dark pattern. As soon as all the petals except those lost into the first washes were identified, my brush was washed almost clean, and some edges were softened again. A few stems and leaf shapes were suggested by holding the plastic spatula at an angle, and squeezing the damp surface to one side.

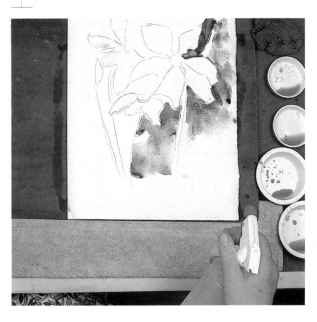

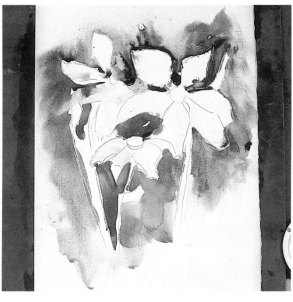

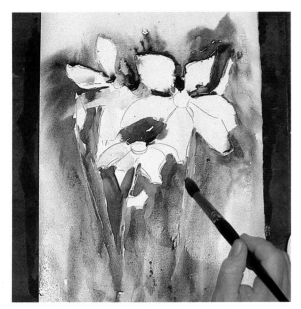

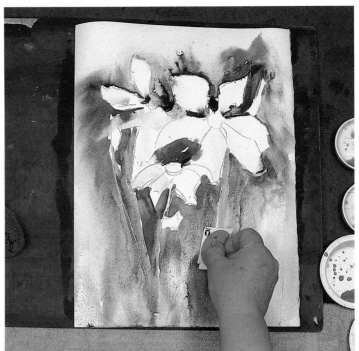

Here is another painting of poet's narcissus with a different color scheme. In this one I used maskoid as described on page 98.

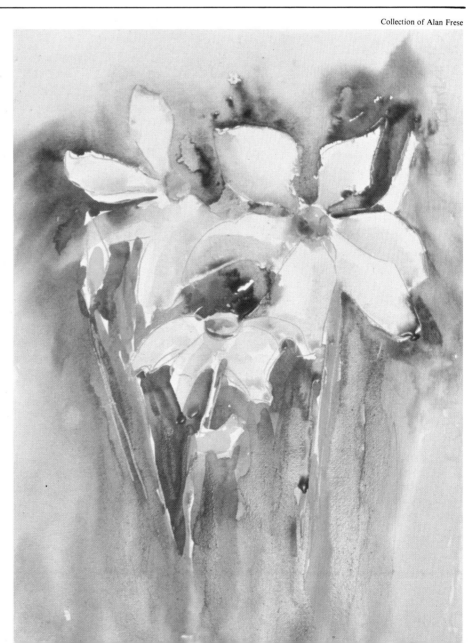

97

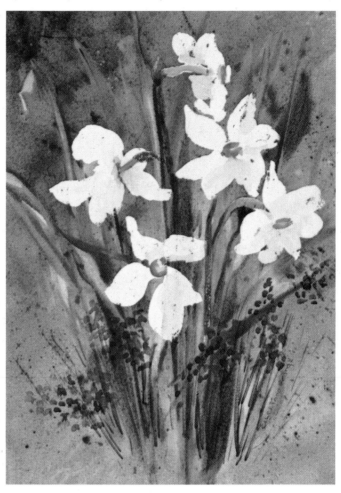

POET'S NARCISSUS
(Wet-in-Wet Technique)

The study of poet's narcissus shown on these pages was done in "wet-in-wet" technique on Arches 140 lb. cold press paper. White areas were masked with maskoid. The painting was done mainly on thoroughly saturated paper.

A preliminary drawing or study is lightly sketched on a quarter sheet of the Arches paper. In this case, the composition was a group of flowers growing in the garden with grape hyacinths in the foreground.

The maskoid was applied with an old No. 5 sable brush which I save for rare uses of masking. The brush was first dipped in water and then given a good shake and brushed over a bar of Ivory soap to keep the maskoid from getting into the brush too deeply. The brush was lightly pointed with a tissue and then dipped into the maskoid. The white petals of the narcissus were painted with strokes following the petal shapes just as though painting the finished flower. I tried to follow the rhythms and create the growth patterns with each stroke. I imagined the petals blowing and twisting in the breeze. When finished, I wiped the brush with a tissue to remove some of the maskoid.

The next step is to soak the paper with a sponge. The table should be covered with a bath towel to catch any water spills. A tempered masonite board, or sheet of heavy glass a little larger than the paper, is placed on the towel. The paper is then sponged first on one side and then on the other until it is saturated. When it is soaked and docile it will lie flat. There should be no air bubbles underneath. Hold the board and paper at eye level to check for air bubbles.

Paint all the large background areas and background leaves before the paper begins to dry. Paint from top to bottom, back to front, large to small and, in general, light to dark. I started with the

background colors of sky, grass and earth.

I used mixtures of cooler blues to warmer blues, cooler greens to warmer greens in gradations of large brush strokes of paint in oblique directions. The blues were mixtures of ultramarine, cobalt and Winsor, mixed with yellow ochre and a touch of cadmium red light.

The greens were made with combinations of yellows and blues, or tube greens with a touch of warm color. This was painted with a flat 2-inch soft brush or camel hair and not overworked. This was done quickly to keep transparency and freshness. Some of the same colors were spattered over the background to create textures, and a quick, light misting from a spray bottle of clear water to create a little more diffusion.

At this point, while the paper was still damp, I suggested some leaf shapes by lifting paint with a thirsty brush, and adding other strokes with a round brush and another half-inch flat brush. I squeezed a leaf shape or two with the plastic spatula scraper. Some leaf shapes were painted with a clear brush squeezed partially dry. Effects of brush strokes at different drying periods and with different amounts of pigment and water differ. This creates leaves with softness as seen in the distance, and others with more defined form to give contrast. The dark accents should be added last.

As the paper begins to dry, it will shrink and lift from the board. Sometimes clips can be used to keep the paper flat. I don't find this necessary, however, with such small paintings.

Allow the paper to dry thoroughly, perhaps for several hours, before lifting or removing the maskoid. If the maskoid is removed before paper is really dry, the white areas can become blurred and discolored by damp paint. To remove the maskoid, masking tape can be pressed over it, and careful lifting will pull the rubbery maskoid with it. Maskoid can also be rolled off by use of a roll or block of maskoid lifter, or with your fingers.

After the maskoid has been removed, the flowers will show up as pure white against a background of middle and dark values. Some of these hard edges can be softened with an old worn-down bristle brush that has been dipped into warm water. Scrub the edge to create a blending of values. Blot it with tissue.

Now comes the painting of the flowers. White is not all white in light and with color around it. White receives light from the sky when outdoors. White also receives light from the sun. Whites directly facing the sun receive more light. If you look at flowers in light, you will be able to see shadows reflected. These shadows are not only changes in value, but also changes in hue created by color reflected onto white.

Reflected light is often bluish. Cobalt works well for this since it is one of the purest blues. Cadmium lemon, cadmium yellow and cadmium orange mixed with clear water as tints work to show reflected color. Start by painting the inside edge of the shadow, and carry the shadow to the edge. Or start by painting the shadow area with clean water and drop the color into this wet area. If the blue and yellow shadows become too green, add a touch of alizarin crimson. This will neutralize the greenish mixture, or gray it.

Keep the color from becoming muddy. Paint with clean water. Do not overwork. Try a light wash. Let it dry. Repeat with other washes. Work from light to dark in glazes. Try other mixtures for shadows on white. Try yellow ochre, ultramarine blue, and a touch of either cadmium red light or alizarin crimson. Vary the values from the darker areas away from the sun to a little lighter areas near the sun. Sneak in a little color of the sky or surrounding foliage.

Shadows give form to the flat all-white shape of the flowers. Shadows tie the flower to the colors in the background. Shadows create pattern within pattern, variations, rhythm and interest.

The centers of flowers painted in this wet technique were added with a few simple strokes of yellow, cadmium red light, and a touch of burnt sienna. The centers were painted as an impression, not as a botanical study.

A leaf or two can be added at this point. A few dots or clusters of dots made with cobalt blue, ultramarine blue, cerulean blue and a touch of alizarin crimson were added near the base of the plants to suggest grape hyacinths and a few slender stems and leaves to suggest their foliage. Don't overdo it. Remember, "Less is more."

CHAPTER 9

Here I am in my long, narrow and cozy studio.

FLOWER PAINTING BY SOME OTHER ARTISTS

Shown on the next few pages are some fine examples of flower painting by a number of other artists. Everyone works differently, in their own way. Who would have it otherwise? Study these examples to see if you can figure out how the artists solved their picture problems. Then try it in your own style.

Some of the artists whose work is shown offered comments about their painting. These are shown below their pictures.

GLENORA RICHARDS, N.A., W.A.

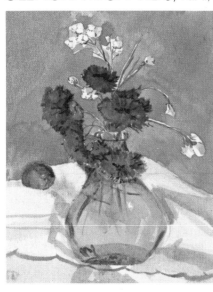

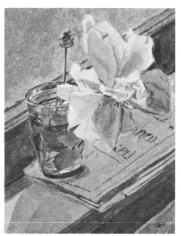

Miniature Paintings Actual size

First I set up a flower arrangement I find attractive, then I try to paint it. That may mean several attempts before I finally arrive at some suggestion of the effect I have been trying to achieve.
I made these flower paintings on Satina hot press Arches paper, and used a No. 3 Series 7 Winsor & Newton brush.
The paints are professional grade Winsor & Newton transparent watercolors.
My palette is kept as limited as possible, usually to five colors.

ALEXANDER ROSS, A.W.S.

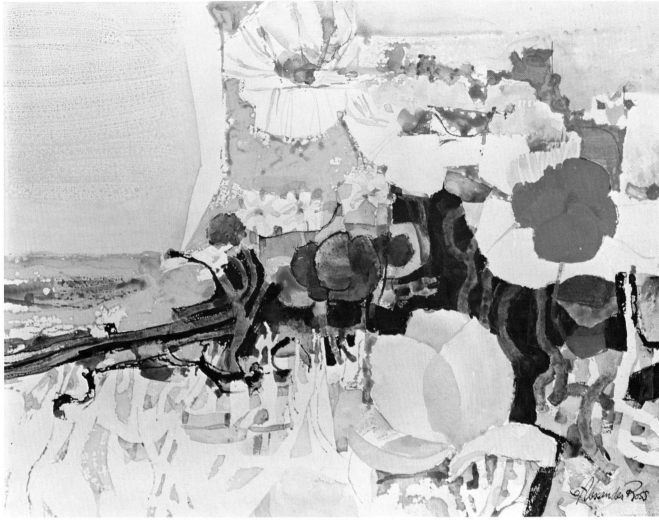

Flower Painting

Alexander Ross

In the study of flowers, or flowerscapes, on which I have been focusing a great deal of my time recently, I am attempting a departure from my traditionally accepted concepts in flower painting by introducing a feeling of nature untouched, or perhaps . . . as an effort to capture the essence of floral forms through some rather unorthodox interpretation.

The beauty of nature is probably most appreciated in the contemplation or study of flowers, and I am not trying to improve on an already perfect phenomenon. Realizing the impossibility of capturing all or part of a flower, a magnificence through paint has turned my mind to thoughts–perhaps metaphysical in their near abstraction–on how to catch a mystical something beyond the beauty our minds and eyes behold.

101

ROBERT LAESSIG A.W.S., A.N.A.

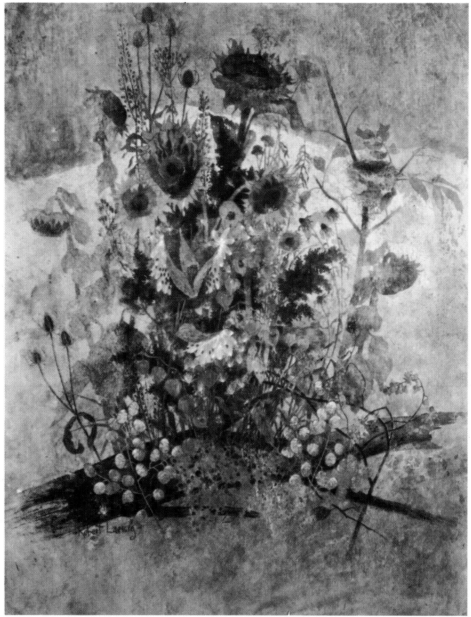

Blue Indigo
Robert Laessig

RICHARD TREASTER, A.W.S.

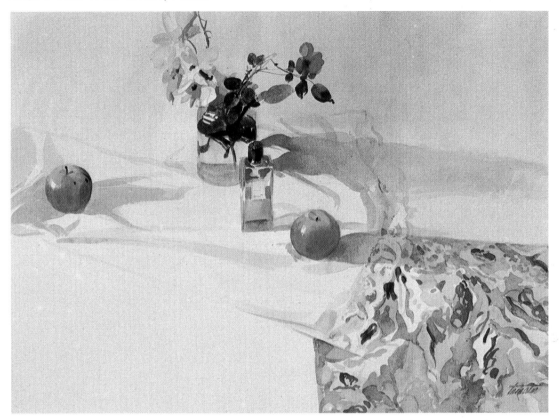

HARDIE GRAMATKY

White Tea Pot 18¾ x 24½
Hardie Gramatky

BARBARA NECHIS, A.W.S.

Spring Palette 15" x 22"
Barbara Nechis

Daisies
Joan Heston

Emily Lorne Memorial Award, 1970 A.W.S.

JOAN HESTON

Usually I approach the painting of flowers in the same manner as still life or figure painting. However, this cluster of daisies looked so lovely and fresh as they were, it seemed they needed no embellishment. My intention was to capture that feeling of freshness and light, and decided a glass vase, crystal clear water, and lots of white paper would help to convey this impression.

I started with a contour drawing for placement and design–a joy with daisies, as their shapes are so varied. The next step was to paint the shadow areas, dropping in color changes, cool and warm, as they were observed, working the entire painting rapidly, moving in and out of the foliage, down into the glass vase, the stems and water, and moving right out into the reflections on the table. When the foliage was dry, I went back in and glazed for dimension and interest, creating a value pattern for the eye to follow. The darks were added last with the expectation that these would be the 'ultimate strokes' to make the painting zing!

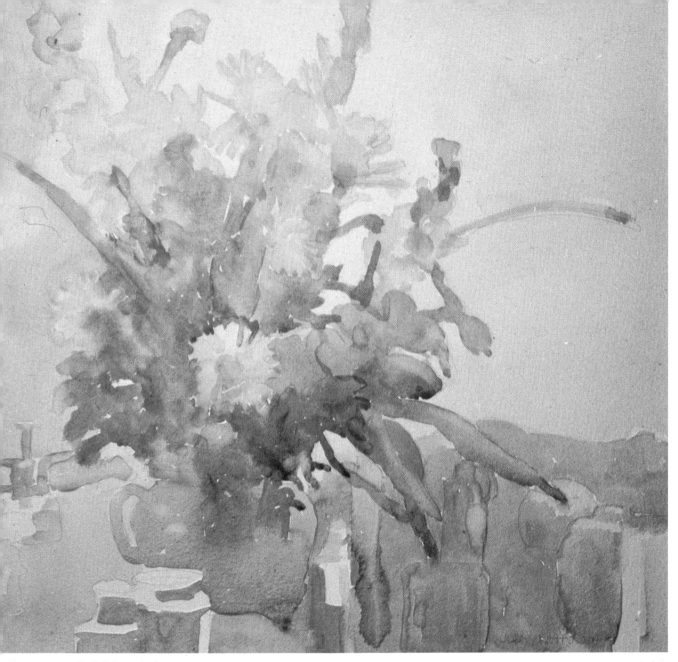

Still Life and Flowers 30 x 22 inches
Judy Inman

collection of Mr.. & Mrs. Theodore Shaw

JUDY INMAN

On Fabriano 300 lb. paper, I start with a contour drawing using #2 pencil. Working on the floor helps me keep a distance from the work. Luckily my knees don't complain about this position.

Good design of values is most important to me, and I often spend more time on value drawings than painting.

I am fascinated with what light does to the colors and shapes of flowers. Because my eye sees too much, I like to simplify and leave something for the viewer to add, teasing his eye to move about the painting.

In painting, a large round #30 sable is my only brush. Untraditionally, I get all my values down in the first wash – there are no second washes.

Sometimes I limit myself to 3 colors, seeing how many different variations I can get. The exciting thing to me about watercolor is the actual "wateriness" which I like to show as well as the colors mixing on the paper.

107

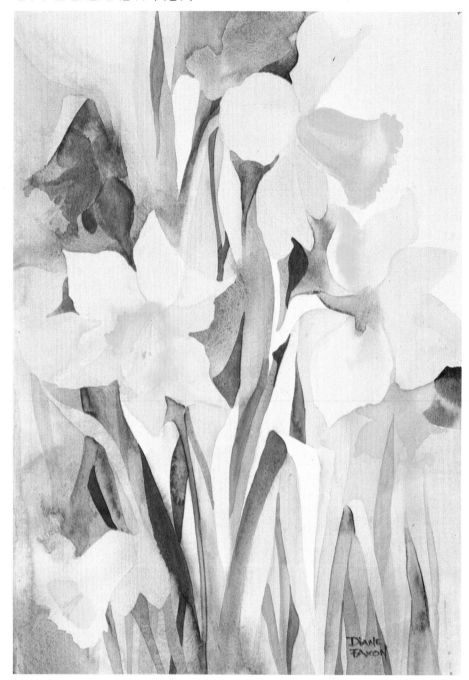

Daffodils in Light 22 x 15 inches
Diane Etienne Faxon

> *When painting flowers I love to squint until what I see are no longer the actual flowers before me, but the glorious lights and darks, the positive and negative forms that the flowers with their leaves and stems create. This is what I try to capture — the interwoven patterns and design of shapes and light. Always new, infinitely exciting. This is usually accomplished by glazing; building up a dark and light pattern, creating what, I hope, is a movement within the painting.*

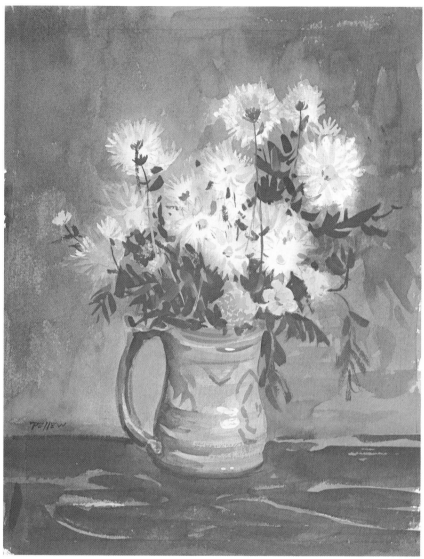

Bouquet 10 x 8 inches
John C. Pellew, A.W.S.

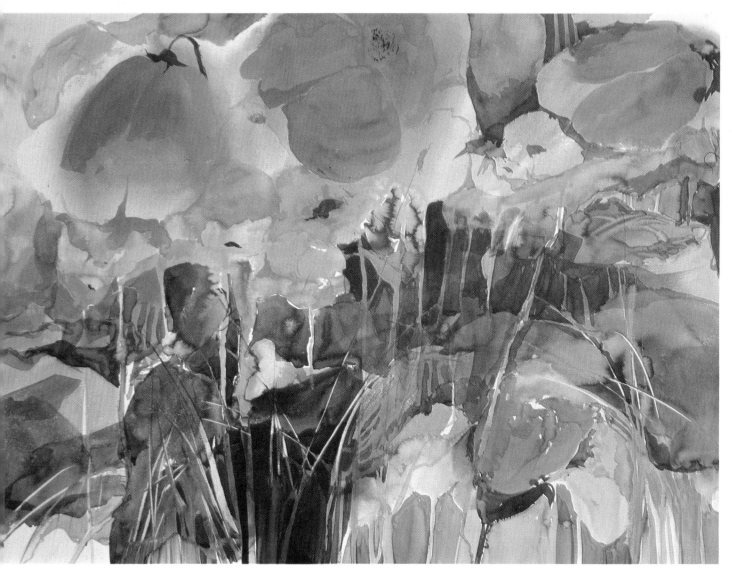

Thinking of Summer
B.L. Green

30 x 40 inches

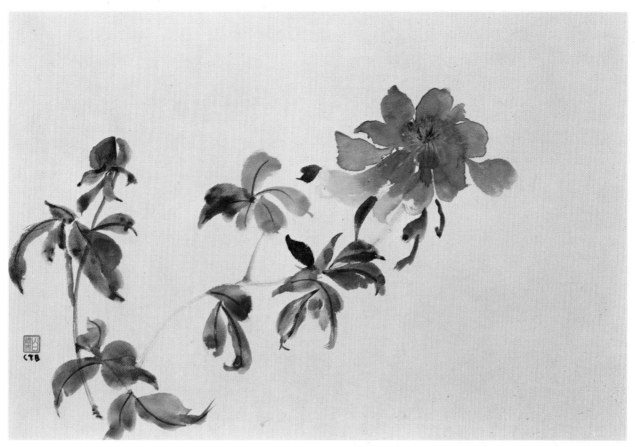

Peony with Bud 14½ x 21
Catherine Turk Ballantyne

CATHERINE TURK BALLANTYNE

The peony is a favorite subject in Oriental Flower Painting and represents Love and Happiness. This picture is painted on rice paper in the "mo-ku" or "boneless" style. The composition is never drawn with a pencil and the artist paints directly on the paper with his brush. In this way he hopes to achieve the "chi" –the very essence of life. One sees many single flowers in Chinese painting because they believe that "less is more."

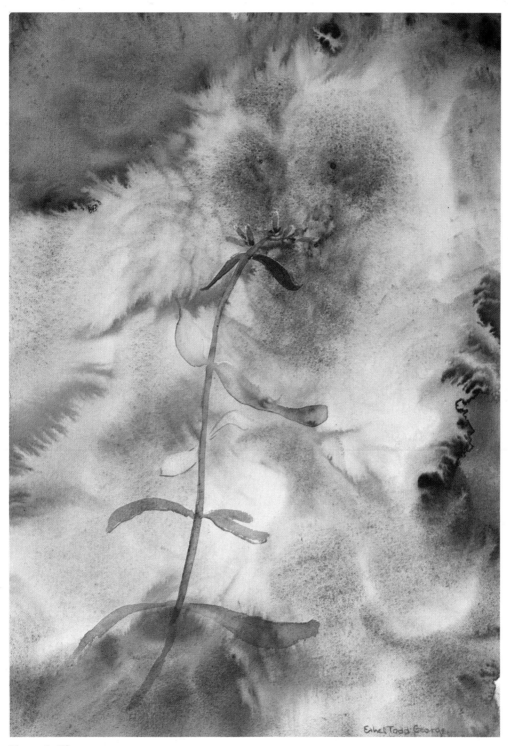

Mountain Flower 22 x 15 inches
Ethel Todd George

CHAPTER 10

OTHER USEFUL INFORMATION

KEEPING FLOWERS CUT FRESH FOR PAINTING

Flowers should be fresh, soft, and pretty for painting. This is best done if the flowers are picked or cut in the cool of the morning or evening. Those picked in the morning contain the most water. Those gathered in the evening have the greatest food reserves. When picked during the heat of the day, they may be wilted and air may enter the stems which contain the water-conducting vessels.

Take a pail of water to the garden so you can put the flowers in as soon as they are cut. Be sure the water is tepid, not cold. Cut the flowers with a sharp knife rather than picking them. Make a 45-degree slanted cut. A knife is better than scissors, which may crush the stems.

Flowers keep better if a floral preservative is added to the water. Anita Ross suggests adding a few drops of Clorox to keep bacteria from entering the flower stems. A solution of sugar and mild bactericide dissolved in water prevents bacteria from multiplying in the water and clogging the ends of stems. Preservatives are available at garden centers and florists. To make water sweet, add 2 tablespoons of sugar to 1 quart of water. To retard bacterial growth and decay when conditioning, add ⅛ teaspoon of boric acid per quart. To make water acid, add 2 tablespoons of white vinegar to each quart of water. Never use these preservatives in metal containers.

When flowers are cut, place them in waxed paper, leaving the top open if you do not have a pail of water at hand. Then, as soon as possible, place them in tepid water. Keep them away from drafts and in a cool area until the water cools. This helps to condition them. Recut the stems of the soft-stemmed flowers and crush the bottom inch of woody branches. Remove all foliage which would be below the water line and also some from stems or branches above, to prevent the blossoms from losing strength.

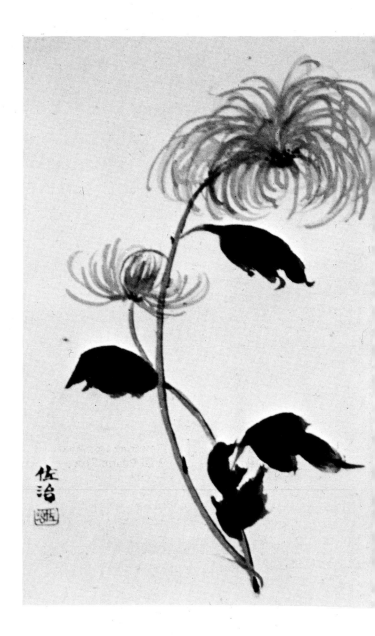

STATE FLOWERS

Alabama	Goldenrod
Alaska	Forget-Me-Not
Arizona	Giant Cactus
Arkansas	Apple Blossom
California	Golden Poppy
Colorado	Blue and White Columbine
Connecticut	Mountain Laurel
Delaware	Peach Blossom
District of Columbia	American Beauty Rose
Florida	Orange Blossom
Georgia	Cherokee Rose
Hawaii	Hibiscus
Idaho	Syringa or Mock Orange
Illinois	Violet
Indiana	Zinnia
Iowa	Wild Rose
Kansas	Sunflower
Kentucky	Goldenrod
Louisiana	White Magnolia Blossom
Maine	Pine Cone and Tassel
Maryland	Black-eyed Susan
Massachusetts	Mayflower
Michigan	Apple Blossom
Minnesota	Wild Lady Slipper
Mississippi	Magnolia
Missouri	Hawthorn
Montana	Bitterroot
Nebraska	Goldenrod
Nevada	Sagebrush
New Hampshire	Purple Lilac
New Jersey	Violet
New Mexico	Yucca

New York Rose
North Carolina Flowering Dogwood
North Dakota Wild Prairie Rose
Ohio Scarlet Carnation
Oklahoma Mistletoe
Oregon Orange Grape
Pennsylvania Mountain Laurel
Rhode Island Violet
South Carolina Caroline Jessamine
South Dakota Pasqueflower
Tennessee Iris
Texas Bluebonnet
Utah Sego Lily
Vermont Red Clover
Virginia Flowering Dogwood
Washington Coast Rhododendron
Wisconsin Violet
Wyoming Indian Paintbrush

FLOWERS OF THE MONTH

January Carnation
February Violet
March Jonquil
April Sweet Pea
May Lily of the Valley
June Rose
July Larkspur
August Gladiola
September Aster
October Calendula
November Chrysanthemum
December Poinsettia

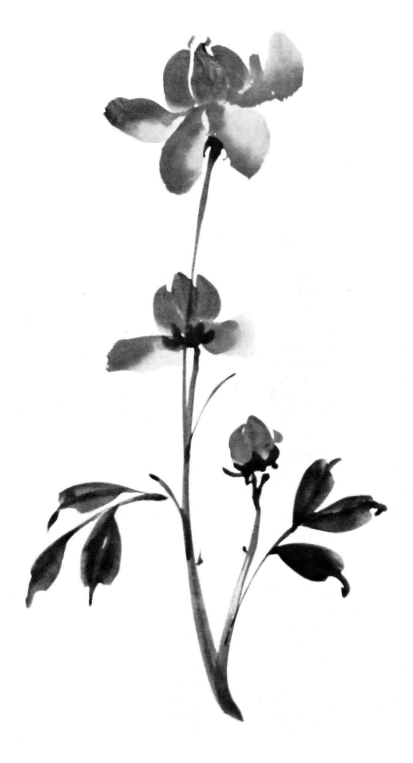

GLOSSARIES

Terms Used with Flowers

Annual: A plant of one year's duration.

Alternate: Leaves not opposite each other.

Anther: The upper enlarged part of the stamen, which develops and carries the pollen.

Axis: A straight line passing through the center of the flowers.

Axil: The upper angle at which the leaf stalk joins the stem.

Bilateral: Arranged or placed on opposite sides.

Bract: A leaf from which a flower, or floral axis, arises.

Bud: A protuberance on the stem of a plant, consisting of undeveloped foliage or flower.

Calyx: The external, usually green, envelope or leafy part of a flower (sepals).

Carpel: An ovary at the base of the pistil. The female sex organ of a flower.

Cleft: Deeply cut.

Compound: (Leaf) divided into separate leaflets.

Cordate: Heart shaped.

Corolla: Inner envelope of a flower, consisting of the petals.

Corymb: A flat-topped flower cluster blooming from the margin inward.

Cupola: A cup shaped part, such as the bottom of an acorn.

Cuspidate: Tipped with a firm, sharp point.

Cyme: A flattish cluster of flowers in which the inner or terminal flowers bloom first.

Elliptical: Equally rounded at each end, widest in the middle.

Entire: (Leaf) without divisions or teeth.

Filament: Thread-like lower part of the stamen supporting the anther.

Genus: Main subdivision of a family, including one or more species.

Inflorescence: A branched structure with flowers.

Involucre: The leaf-like bracts surrounding a single flowerhead, or cluster.

Lanceolate: Lance shaped.

Leaflet: A single division of a compound leaf.

Oblanceolate: Lance shaped at the base; widest at the tip.

Obovate: Egg-shaped, but broadest at the tip.

Ovary: The broader base of the pistil in which the seeds develop.

Palmate: (Leaf) divided, as the fingers on the palm.

Panicle: A compound, elongated, branched flower cluster.

Pedicel: The stalk of a single flower.

Perennial: Living year after year.

Perianth: The whole floral envelope, both calyx and corolla together.

Petal: A division of the corolla.

Pinnate: (Leaf) compound, with leaflets arranged along the midrib, often in pairs.

Pistil: The stigma, style, and ovary, taken together.

Pollen: The powder-like yellow male sex cells on the anther of the stamen, for pollinating the flower.

Raceme: Few to numerous stalked flowers along an elongated axis.

Sepal: A lobe of calyx, usually green, under the petals.

Serrate: Notched or toothed on the edge.

Sheath: A tubular envelope enclosing an organ.

Species: A single, distinct kind of plant; subdivision of a genus.

Spike: Few to many sessile flowers on an elongated stalk.

Stamen: The pollen-bearing organ of a flower.

Stigma: The organ that receives the pollen at the top of the pistil.

Style: The slender upper stalk of the pistil that bears the stigma.

Succulent: Fleshy, juicy.

Umbel: A flattened flower cluster with the stalks radiating from the same point.

Whorl: (Leaf) radiating from the same level on the stem.

Terms Used with Painting Flowers with Watercolor

Abstract art: Art which depends entirely upon patterns of form, line, color, and does not have to be associated with motif or theme.

Academic painting: Painting which conforms to traditional conventions associated with the teaching of academies.

Advancing colors: Warm or hot colors in relation to the surrounding colors. Colors which seem to advance in a picture.

Aerial perspective: Creating the illusion of distance by gradation, shade, and color—as though seen through layers of air.

Aquarelle: A watercolor painted in transparent colors.

Binder: Any material which binds together particles of pigment; for example, oils, resins, glue, gum and casein.

Body color: Watercolor paints mixed with white to make them opaque.

Broken color: Color broken up by the introduction of other colors, like dots of different colors placed side by side.

Calligraphy: The art of handwriting. Oriental artists are calligraphers by training with free, rhythmic brushwork.

Camel hair: A term used for brushes usually made of squirrel hair.

Cast shadow: Shadow which is cast by one object upon another. One petal of a flower or a leaf can cast a shadow upon another.

Chiaroscuro: A painting or drawing in which strong emphasis is placed on light and shade.

Color circle: A common arrangement of colors around a circle in the order of the rainbow. One half of the circle contains warm colors such as red, orange and yellow; and the other, cool colors such as green, blue and violet. Complementary colors are opposite each other. Swift spinning of a color circle produces an illusion of white. White light is composed of all colors of the spectrum.

Contained shadow: The shadowed side of an object. The side away from the light as distinct from cast shadow.

Earth colors: Pigments which owe their hues to metallic oxides like umber, terre verte and Venetian red.

Easel: An adjustable stand or frame to support a board or canvas for the painter or viewer.

Eye level: The horizon line to which, in perspective, all receding parallel lines converge, to meet at vanishing points.

Fixative: A thin varnish sprayed onto drawings to preserve them from rubbing. Shellac and methylated spirits can be combined to make a fixative.

Foreshortening: Perspective drawing applied to create the illusion of depth such as a form coming toward or going away from the viewer.

Gesso: A mixture of whiting material such as gypsum or titanium white mixed with a glue used to cover a paper, canvas or board as a ground for painting. It can be purchased ready-made and can be used to create certain effects in watercolors.

Glazes and glazing: Thin films of translucent color applied to an already dried painting. Sometimes a glaze can be applied with a large soft brush to the entire painting to give it unity. Areas can be glazed to create luminosity and variations.

Gouache: A French word for opaque watercolor. Watercolors can be made opaque by the addition of white paint.

Graduated color: Color which passes gradually from one shade or tone to another or from light to dark, warm to cool.

Gum arabic: A product of various trees which is used as a binder for watercolor pigments.

Hatching: Building up tone by a series of small, close parallel lines and crossing them with another series of small, close parallel lines to produce tone effects, textures and shadows.

Hue: The name of a color such as red, orange, yellow, etc.

Linear perspective: A means of determining the planes in recession with lines and mechanical means, as distinguished from aerial perspective.

117

Local color: The color of flowers and foliage without regard to effects of light, cast shadows, distance or atmosphere.

Luminosity: Brilliance created by glazing with transparent colors over lighter colors, creating the effect of radiant color like light seen through laminated glass windows.

Mahlstick: A slender rod with a soft padding on the end. Used to support the arm away from a wet painting as the artist works.

Masses: The fundamental shapes of groups of flowers or plants within the picture.

Medium: The substance which holds pigments together. For watercolor the medium is gum arabic.

Middle distance: When different planes are distinguished in landscape painting, they are called foreground, middle, and far distance.

Mixed media: A combination of two or more mediums in one picture such as painting with watercolor, ink, crayon or other similar combinations.

Monochrome: Painting in one hue only, but the values and intensity may vary.

Motif: The theme or idea of a picture or pattern.

Movement: The rhythmic flow through the parts of a painting.

Muddiness: Painting which through overwork, or working with light over dark colors, becomes too mixed and takes on a muddy rather than a fresh appearance.

Neutral tones: Tones which act as a foil to positive colors. Grays.

Objective painting: Painting from nature, or realistic painting as opposed to abstract or non-objective.

Oblique perspective: Perspective of an object or flower turned at an angle to the picture plane.

Opaque color: Colors which absorb the rays of light and are not transparent.

Painterly: Pictures that show qualities of painting techniques.

Palette: A wooden, plastic, enamel or glass implement used to set out and mix the pigments.

Picture plane: An imaginary plane at right angles to the observer's line of vision and upon which the view to be painted is mentally projected.

Plein air (open air): Pictures painted out of doors imparting a feeling of open-air and atmosphere. Usually not as detailed as those painted in the studio.

Primary colors: Colors which cannot be made by mixing. They are yellow, red, and blue. By combining two or more of the primaries in proper proportion many other colors can be created.

Reflected color: Color which is reflected from one surface upon another.

Reflected light: Light which is reflected back into a shadowed surface.

Separation and sediment: When using two colors together, the heavier pigment sinks first, tending to separate the colors. A granulated effect is caused by using two watercolors with a pronounced tendency to separate.

Shade: A color or tone. To indicate shadows by graduated tones.

Sketch: Usually a preliminary drawing or painting to determine the composition or other factual information. Elements of freshness and spontaneity are characteristic of sketches. Sketches are not necessarily "rough."

Splatter: See Chapter 2. Splattered color made by dipping a stiff brush in paint and dragging it over a stiff tool or fingernail.

Stencil: A pattern often cut from waxed paper or metal, used to apply design or lift an area of color with a damp sponge.

Symbol: A recognizable or abstract idea of the subject.

Tempera: This term originally applied to paint in which dry pigment was mixed with an emulsion such as egg yolk. Now it usually refers to opaque watercolor in general.

Texture: There are several kinds of texture. One is surface texture, such as rough, smooth, hard, soft, etc. Another kind of texture can be made by repeating forms of a similar shape. There is also two-dimensional texture such as a flat pattern or design on the surface such as wallpaper.

Underpainting: This is a method of painting in which the first application is done lightly with thin color and successive layers or glazes of additional color are added.

Value: Value and tone are often interchanged in usage. It means the lightness or the darkness of a color.

Vignette: A painting or design of irregular border often having little or no background.

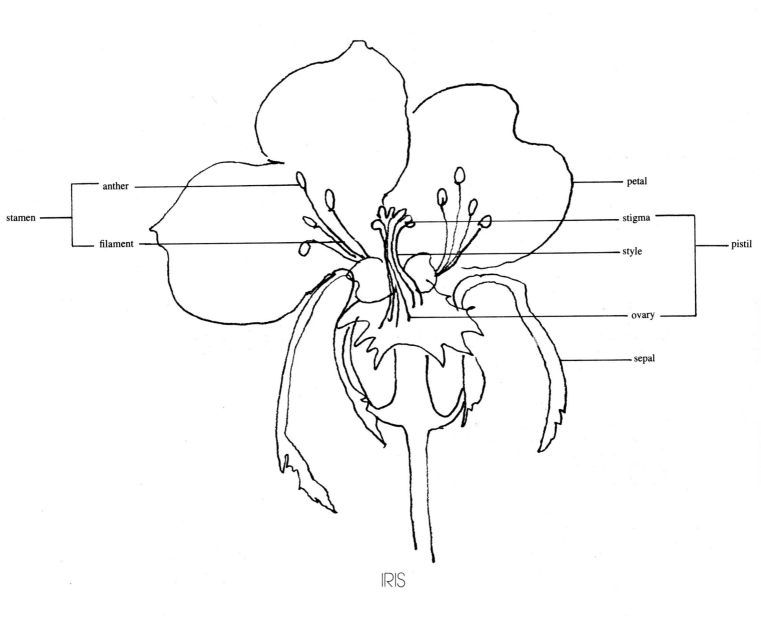

stamen

anther

filament

petal

stigma

style

ovary

pistil

sepal

IRIS

119

Rose

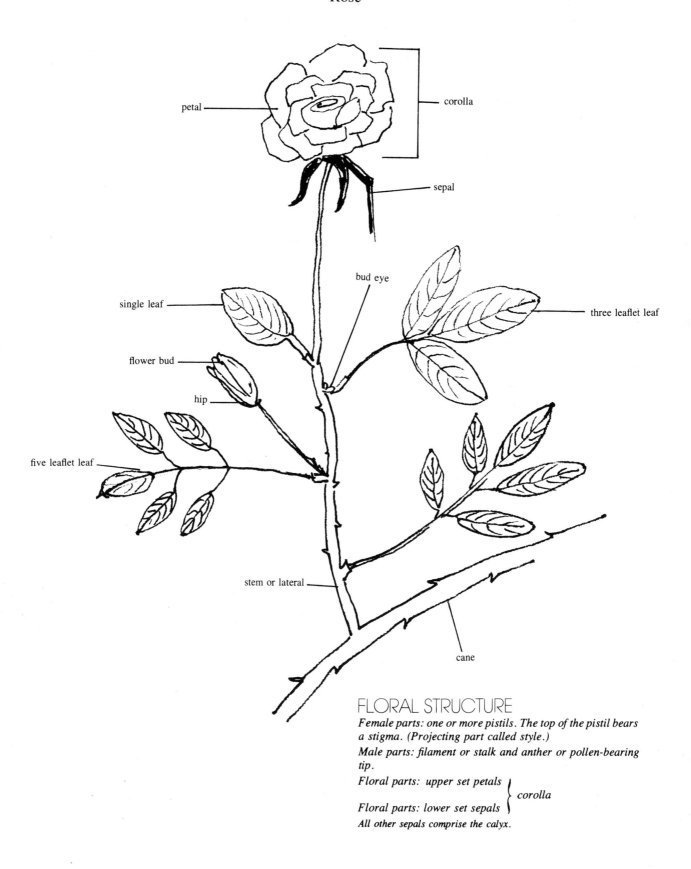

petal

corolla

sepal

bud eye

single leaf

three leaflet leaf

flower bud

hip

five leaflet leaf

stem or lateral

cane

FLORAL STRUCTURE

*Female parts: one or more pistils. The top of the pistil bears
a stigma. (Projecting part called style.)*

*Male parts: filament or stalk and anther or pollen-bearing
tip.*

Floral parts: upper set petals

} corolla

Floral parts: lower set sepals

All other sepals comprise the calyx.

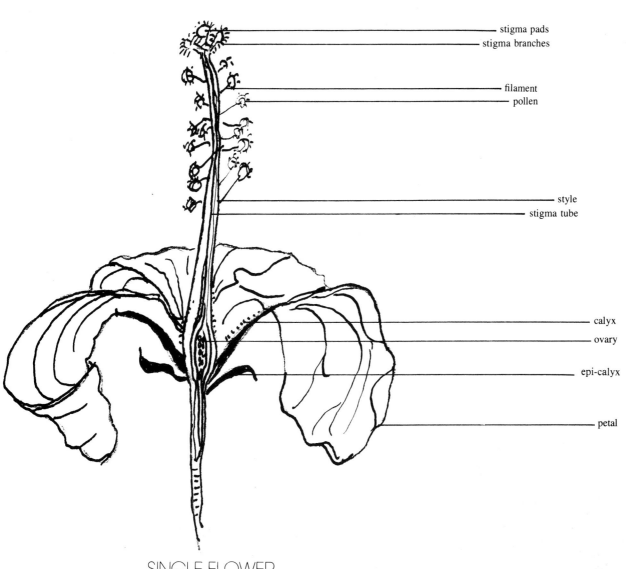

stigma pads
stigma branches

filament
pollen

style
stigma tube

calyx
ovary

epi-calyx

petal

SINGLE FLOWER

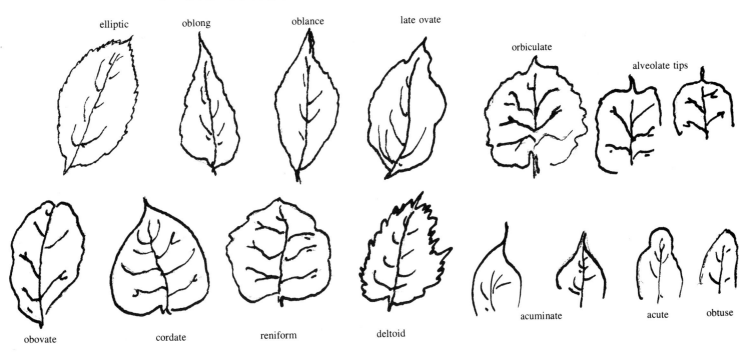

elliptic oblong oblance late ovate orbiculate alveolate tips

obovate cordate reniform deltoid acuminate acute obtuse

STUDIES OF HIBISCUS AND LEAF FORMS

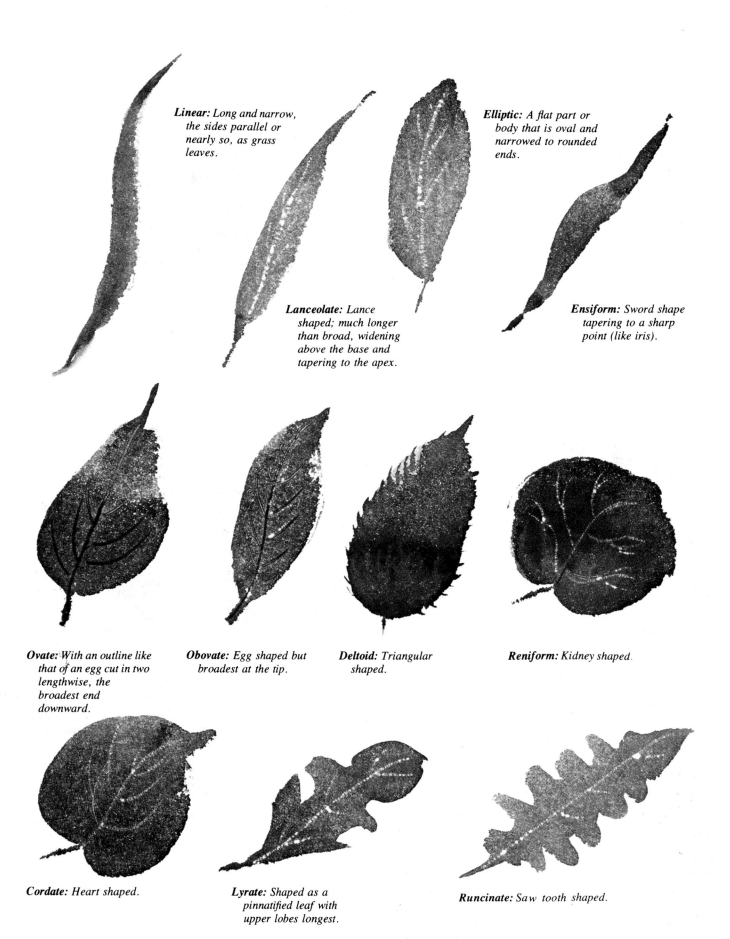

Linear: *Long and narrow, the sides parallel or nearly so, as grass leaves.*

Elliptic: *A flat part or body that is oval and narrowed to rounded ends.*

Lanceolate: *Lance shaped; much longer than broad, widening above the base and tapering to the apex.*

Ensiform: *Sword shape tapering to a sharp point (like iris).*

Ovate: *With an outline like that of an egg cut in two lengthwise, the broadest end downward.*

Obovate: *Egg shaped but broadest at the tip.*

Deltoid: *Triangular shaped.*

Reniform: *Kidney shaped.*

Cordate: *Heart shaped.*

Lyrate: *Shaped as a pinnatified leaf with upper lobes longest.*

Runcinate: *Saw tooth shaped.*

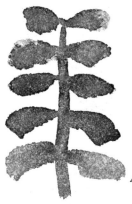

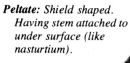

Peltate: *Shield shaped. Having stem attached to under surface (like nasturtium).*

Abruptly-pinnate: *Even number of feather shaped leaves.*

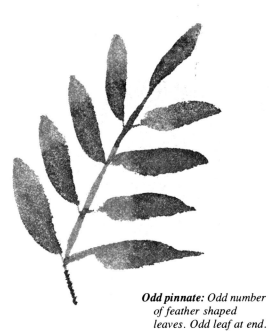

Odd pinnate: *Odd number of feather shaped leaves. Odd leaf at end.*

Trifoliate: *Cluster of three leaves.*

Quinquefoliate: *Cluster of five leaves.*

Leaf terms:
Alternate: *Not opposite each other.*
Bilateral: *Arranged or placed on opposite sides.*
Bract: *A small leaf-like structure, usually under the flower.*
Compound: *Leaves divided into separate leaflets.*

Deciduous: *Leaves lasting but a single growing season, falling in autumn.*
Distinct: *Separate, not united.*
Downy: *Covered with soft, fine hairs.*
Petiole: *The stalk of a leaf.*
Viscid: *Sticky.*
Sessile: *Without a stalk, as a leaf.*

Leaf Patterns

collection of Cliff and Shirley Keith,
Court Galleries, Cincinnati, Ohio

I did this large painting on a half-sheet of 300 lb. Arches paper. Lifts and stencils were used to create the overlapping effects.

Fall Dogwood 28 x 36 inches

Dogwood makes a lovely subject anytime of the year. Notice how I repeated the shapes and values of the small leaves to create a pattern running diagonally across the composition.

Tulips At Treetops